Celebrating Buffalo's Waterfront

Written by Captain Bill Zimmermann & Mark Donnelly, Ph.D.

Photography by Mark Donnelly, Ph.D.

Foreword by Mike Vogel

RPSS Publishing • Buffalo, New York
www.rpsspublishing.com

RPSS Publishing, 429 Englewood Avenue, Buffalo, NY 14223
publisher@rockpapersafetyscissors.com

978-1-7340139-9-3

Second Edition

21 20 19 18 17 6 5 4 3 2

Printed in the United States of America

As a city and as a region, we are completely inseparable from our waterfront.

It's an embarrassment of wealth that is our connection
to our past, present, and future.

We depend on this water for our power, recreation, industry, and agriculture.

It has separated us in war, and it's what binds us in peace.

And for good and for bad, it dictates our weather.

It's our identity to the world, reflecting our radiant beauty.

In short, our water is the glue that binds us together.

This fluid connection, however, is only a magnificent illusion.

The same water we gaze out upon today isn't the same water we'll see tomorrow.

While seemingly abundant and permanent, our glue is constantly racing away
at the staggering rate of 750,000 gallons per minute.

We dedicate this book as a

Celebration of its Journey.

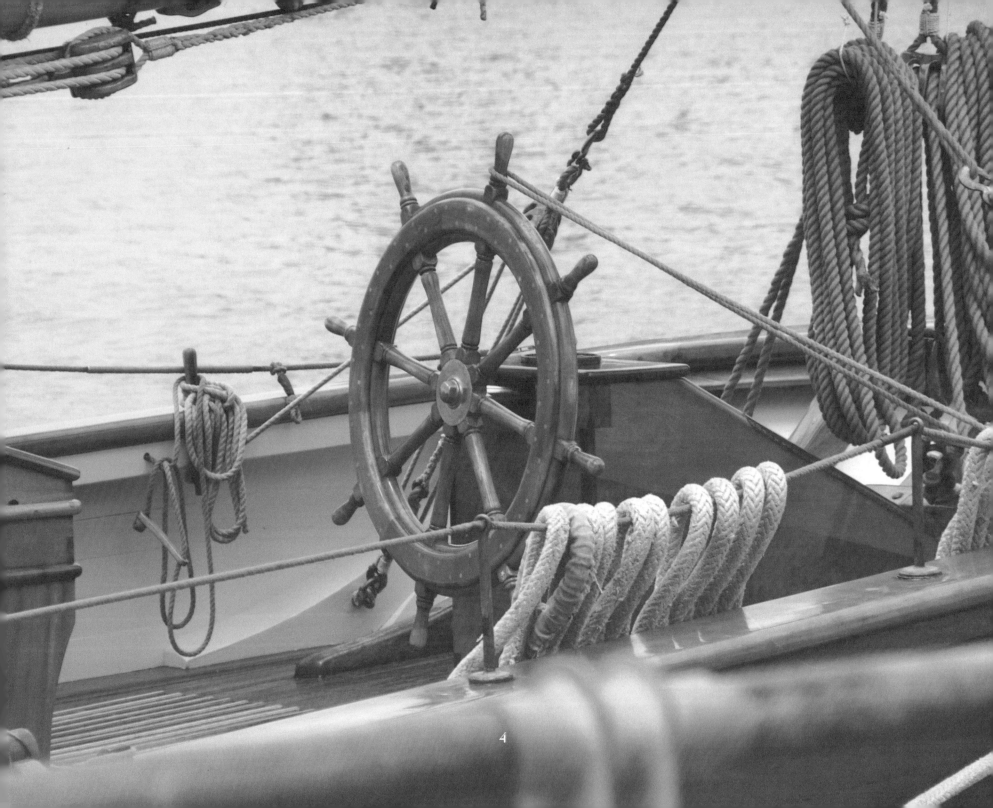

Navigating this Book

"Moving Foreword" 7

Buffalo's Magnificent Waterfront 13

A Very Old, Overnight Success 19

Our Industrial Heritages 27

 The Buffalo Harbor Museum 32
 Fireboat Edward M. Cotter 34

Inner Harbor 36

Erie Basin Marina 38

Buffalo Niagara Naval Park 41

 Heroes Walk 45

Canalside 46

 A Remarkable Transformation 49
 A Thriving Vortex of Activity 51
 Canalside is a Kid's Paradise 52
 Winter Wonderland 55
 It's where happenings happen 56
 The Longshed Building 58
 Buffalo Heritage Carousel 58
 Explore & More 61

Queen City Bike Ferry & Landing 63

Outer Harbor 64

 Buffalo Lighthouses 67
 Pedal Power 71
 Buffalo Harbor State Park 73

On the Water 75

 Sailing 79
 Rowing 80
 Tours 83
 Fishing 88

Yours To Enjoy 91

 Art Is Everywhere 92
 Parks & Gardens 94
 Nature 99
 A Place To Simply Relax 101

Epilogue 103

About the Authors 104

(Opposite:) Ships wheel of the tall ship Appledore V at the Basil Port of Call: Buffalo - *Photo courtesy of Robert W. Kinkaid*

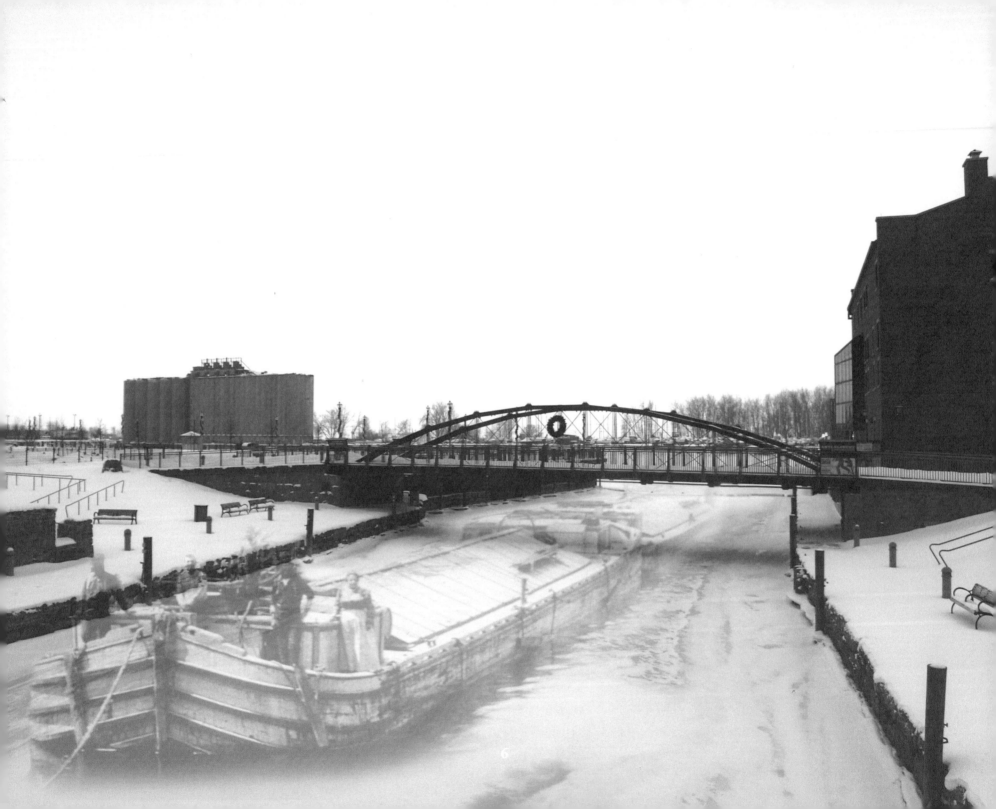

"Moving Foreword"

A bit more than three decades ago, I helped produce a Buffalo Harbor book that paired historical photos of its heyday with modern pictures of the same view taken from the same spot.

It is now terribly out of date.

As the pictures in this new volume show, a lot has happened in those 30+ years. Most of the photos we took of the waterfront back in 1989 are just as deeply relegated to history as the much older ones we used to show what once was the commerce of a world-class port. We didn't think of it then as documenting just another chapter in history; *Waterview Guide to Buffalo Harbor*, now long out of print, was just an effort to capture the present and help the user see what the same place once held.

Looking back on it, it seems pretty depressing. The "new" photos were taken near the time when Buffalo's economy and its waterfront both were bottoming out. Bethlehem Steel had shut down its massive operation at the southern end of the harbor in the early 1980s, costing this region thousands of jobs, and the ripples of that were still being felt.

The once-bustling industrial waterfront was all but dead. The years afterward left it almost abandoned.

But then came rebirth.

The book you're holding is an update of a book first published in 2014, documenting the amazing start of that change. The progress he includes in this volume borders on incredible. And, as I revisit this forword, the Erie Canal Harbor Development Corp. board of directors I sit on is preparing to roll out a 20-year, $150 million redevelopment plan for the Outer Harbor. The Inner Harbor plan already in place dwarfs that, at an estimated $460 million with much of that in private investment that's under way. And Canalside is drawing 1.5 million visitors a year.

I spent 41 years as a Buffalo News journalist, and for many of them, the city newspaper had me covering the burgeoning hopes, dreams, and planning for a new and different waterfront. Through the years, I visited more than 40 redeveloping urban waterfronts, mostly in the United States, to see what was working and what wasn't. The News, recognizing the importance to Buffalo's future of this potential resurrection of its storied past, committed a lot of my time to that. There were news stories and analytical pieces, including a magazine-length look at developing themes in this waterfront's renewal that won the American Planning Association's top national journalism award more years ago than I care to remember. There were long hours on the water; days spent poking into the nooks and crannies of working and gentrified waterfronts across the country, and time spent learning from planners, doers, and dreamers.

And not much came of it.

Until fairly recently, anyway. If you look around Buffalo's waterfront today, there are construction sites and towering cranes. There also are public gathering spaces and the new bustle of waterfront activities – look at the pictures and read the text in this book, and you'll see what I mean. At this writing, the transition from an industrial port to the abandoned shoreline to the recreational waterfront is in full swing; there's a lot yet to come, but I'm no longer envisioning the future and wistfully thinking, "but not in my lifetime." Now, I'm actually seeing it.

And, retired from journalism, I'm seeing it now from a new perspective – that of Buffalo's lighthouse keeper. I don't actually tend the light in the historic 1833 tower that graces the entrance to the Buffalo River and the city's inner harbor, or the 1903 South Buffalo Lighthouse that offers the other cultural and historic "bookend" at the southern end of the outer harbor; both, like the waterfront itself, went dark years ago. But both too are being reborn, the lighthouses as part of the Buffalo Lighthouse Association

(Opposite:) An early canal boat arriving at the Erie Canal terminus combined (with a little Photoshop magic) with recent photo of the Commercial Slip at Canalside.

preservation effort that I helped found back in the mid-1980s and still lead. It had seemed to me that I should put my personal time where my media mouth was, and I was blissfully unaware then that keeping discontinued lighthouses would be a lot harder than it sounds.

But the top of a lighthouse does offer a fine vantage point. For the last 35 years, I've been able to see a lot of change. The Buffalo Lighthouse itself, built just a few years after the opening of the Erie Canal, has stood sentinel to far more — so perhaps an even longer perspective is in order.

In 1798 Buffalo was just a small waterfront hamlet; eight families in seven log cabins with war-displaced Senecas from mid-state New York settled nearby. It was named a federal Port of Entry in 1805, but it was still just a speck on the frontier map, and it was only marginally bigger when the War of 1812 swept that frontier and British forces burned almost everything to the ground at the very end of 1813.

The Erie Canal changed all that. The engineering marvel of the 19th century, it linked the Atlantic to the Great Lakes via a waterway that opened the heartlands to the world and drove American expansion westward. Buffalo grew exponentially as a portal for a flood of immigration and a transshipment port for a river of goods, raw materials, and commerce that flowed in both directions. In 1819, six years before the canal's completion, there were 500 residents in the village; fifty years later, there were nearly 100,000.

Years ago, I had the chance to get involved in some archaeology down on the waterfront. Several feet down, we ran into layers of oyster shells. Imagine that, oyster shells. Oysters don't come from the Great Lakes, so why were they here? In short, the broken shells once paved roads – and they were here in great supply because the Erie Canal made it possible to ship reasonably fresh oysters this far from the coast, to the immeasurable delight of relocated easterners who reunited with a favorite food!

Before the canal, the port was home to four or five small trading vessels; fifty years later, there were 1,400 ships on the lake, and on the canal, there were more than 3,000 boats moving more than a half-million tons of cargo a year.

The early trade in furs and package goods gave way to rivers of bulk cargoes, grain and ore, and lumber and coal. All along the waterfront, wharves and pilings fronted freight-forwarding houses, sail lofts, grain elevators, and other enterprises; manufacturing, everything from iron foundries to birdcage factories, sprang up to take advantage of the water highway. The harbor built Buffalo. The Forest Lawn gravestone of Judge Samuel Wilkeson, its first harbor builder in 1821, reads *Urbem Condidit* – He Built the City.

The inner harbor, the Buffalo River shoreline near the foot of Main Street, was home to the Central Wharf and much of that city's early economic activity. Behind it, the Canal District offered both a commercial zone and an infamous red-light "infected district" along Canal Street and its byways where bars and brothels catered to sailors and canawlers paid off at the end of their respective voyages from the west and the east. They didn't like each other much, either, making this one of the universally-acknowledged roughest waterfronts in the world.

That would pass, as railroads ate into the canal trade and the buildings of the district became tenements. But the commerce continued to grow, expanding along the Lake Erie shore in the years after the Civil War as the federal government, grateful for Buffalo's industrial support of the Union effort, created an outer harbor by building the longest rubble-hearted breakwater in the world.

In 1898, 108 million bushels of grain reached the port, and Buffalo's waterfront storage elevators reached 221 million bushels. By 1900, the lumber trade of Buffalo and the Tonawandas was the largest in the world. Only Chicago and New York City surpassed Buffalo's cargo totals in the United States, and Buffalo ranked seventh among the world's ports in tonnage. There was still some vacant space along the outer harbor, but 23.6 miles of Buffalo's 37.38 miles of waterfront were crammed with businesses, industries, and docks.

The openings of the Panama and Welland Canals in the next few decades began the long decline of the transshipment port, but still, there was

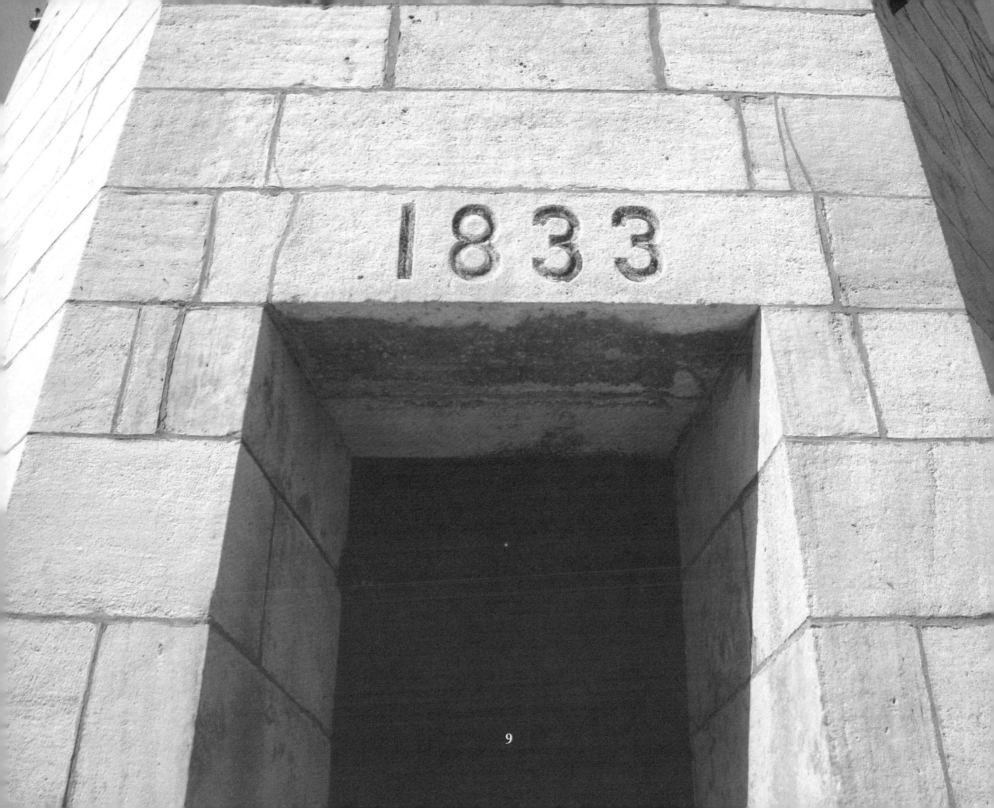

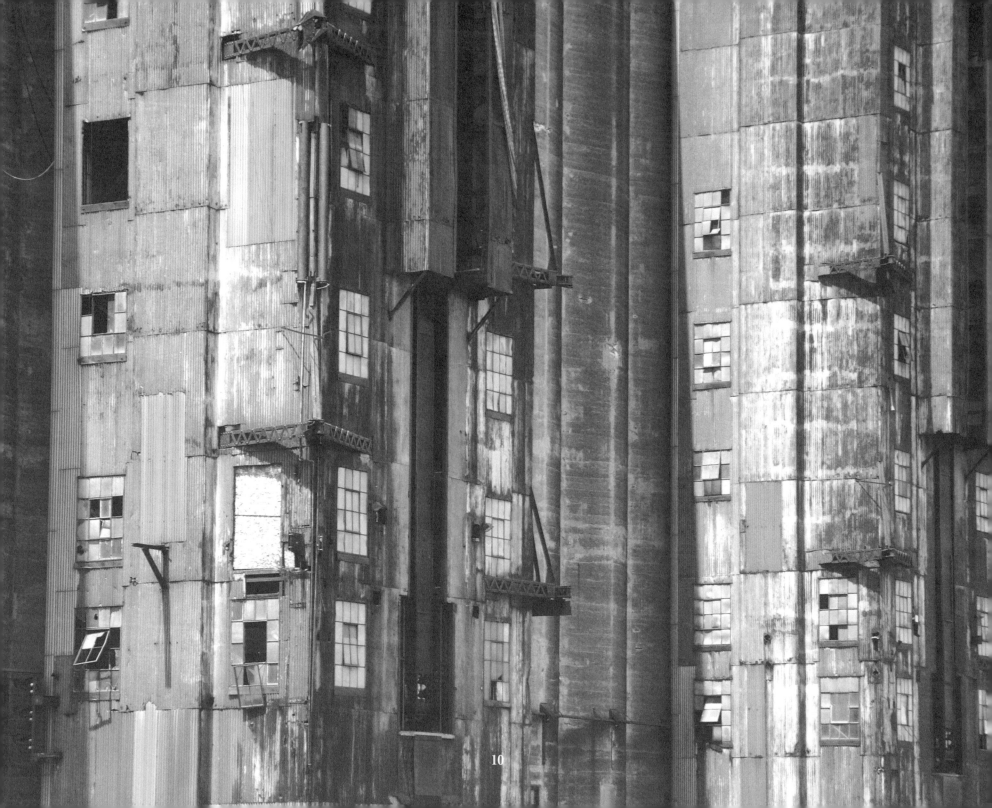

prosperity. The opening of the Mesabi Range's ore deposits and the development of steel industries here made Buffalo second only to Duluth among Great Lakes ports by 1923 in tonnage and first in cargo value. In 1924, a record 124 lakes freighters were anchored in the outer harbor as the winter grain fleet, storing grain the city's array of towering grain elevators could not hold. But the port rankings slipped through the 1930s. World War II production and the end of the Great Depression offered only a brief return to glory; the all-time record of 24.3 million tons of cargo was set in 1940, and another all-time record of 257,340,677 bushels of grain was set in 1945.

In the mid-1950s Buffalo Harbor still was America's biggest inland port, the world's largest flour and milling center and the country's second-biggest rail hub. But the industrial decline would accelerate after the St. Lawrence Seaway was completed in 1958, opening a direct path to the sea and eroding the city's prime geographical advantage as a place where cargos could be, had to be moved from one form of transportation to another.

There still are vestiges of that past. Many of the towering grain elevators, industrial icons that spurred an entire movement of modernist architecture, still stand. Other reminders also are there, if you know where to look – in the configuration of slips and inlets, for example, or in a nature preserve lake that once was a turning basin lined with lumber docks. The elevated road-way that carries Route 5 the length of the water-front wasn't envisioned as the berm it now is; it was supposed to be a bridge on pillars that would allow unfettered truck and train access to water-front industry, until budgetary concerns changed those plans. The Skyway portion of that route,

opened in 1954, was built to carry road traffic high up and over the freighter traffic that once frequented the channel.

Back when urban waterfront renewals started gaining steam nationwide, there was a lot of talk about the importance of preserving elements of the "working waterfront" to give context and add heritage to shoreline renaissance. But much of that working waterfront has been lost here. Lakes freighters still call, but far fewer of them, although each of today's long modern vessels carries the cargo of several older-style ones. Aside from the elevators, much of the shoreline infrastructure has vanished. Today, preservationists fight to save what's left.

That still is a fight. There are tensions between those who want to develop a new, activity-packed and modern waterfront with an emphasis on economic development, and those who reject any hint of a cookie-cutter approach and insist on a uniquely Buffalo harbor with an emphasis on the environment and the rich history and heritage that sets this place apart. But both sides agree on one thing – in fact, the single thing that surfaces as the major consideration and prime goal whenever a survey of waterfront needs is taken: public access.

And that is precisely as it should be. Modern urban waterfronts, above all, should bring people to the water (and make them drink, if planners adhere to the standard success formula of beer, bands and boats, but that's an argument for another day).

There is a basic human need at work here, and successful waterfront plans acknowledge and capitalize on that. If there is magic anywhere on

this planet, an early waterfront planner once said, it exists in water. And there is a special magic in the border between land and water; people are drawn naturally to either the center or the edges of things, and the edge of a shoreline evokes a response deep within the core of human nature.

And it can be just plain fun.

That's what the photographers and writers who envisioned this book seek to convey. They rightly have sought to cover the range of activities and interests at this stage of a still-growing transition from industrial to recreational waterfront.

Enjoy the book. Better still, get out there and enjoy the waterfront.

And while you're doing so, pause just a moment to consider the heritage and the path that got us to this place – and dream a little bit about where we might be headed in our shared waterfront future.

Mike Vogel

October 2020

Mike Vogel is a veteran historian, preservationist, and journalist who has been actively involved with the Buffalo waterfront for more than 40 years.

Vogel is a director of the Erie Canal Harbor Development Corp. and has chaired its Canalside History Advisory Group for the past four years, working with other local historians to develop interpretive elements that will help tell the story of the Erie Canal and the Great Lakes' historic juncture.

Mike founded the non-profit Buffalo Lighthouse Association to restore the city's iconic 1833 lighthouse.

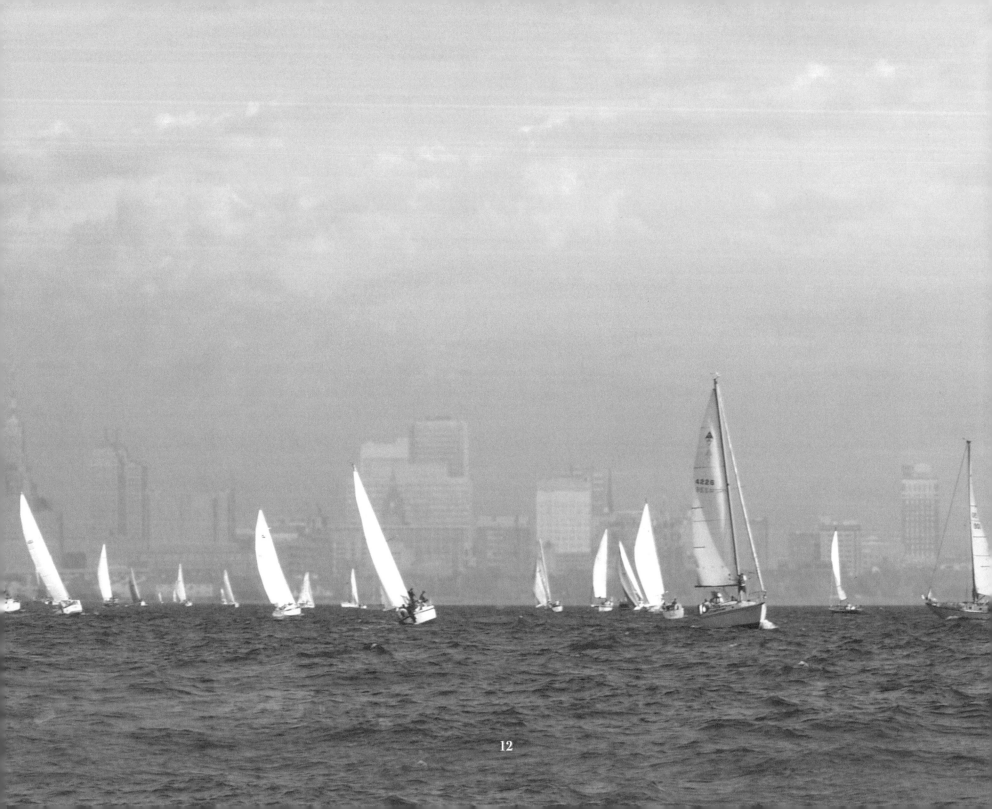

Buffalo's Magnificent Waterfront

"Books are lighthouses," wrote 19th century author Edwin Whipple, "erected in the great sea of time." If we are to properly see our waterfront in all its magnificence, past, present and future, we might want to travel back starting with changes over geological time.

Long before the City of Buffalo began as a tiny village by the water, located at the nexus of the Buffalo River and Lake Erie, our region saw many transformations stretching back over 10,000 years. Today we can muse about the magnificence of our modern day waterfront, but also imagine how evolution got us here and now.

Dress warm for our time tour, for it was cold back then. Like many a tourist to our region, we proceed first with a visit to our neighboring Niagara Falls, which was formed about 10,000 years ago. Considering that its nearby escarpment developed many millions of years ago, the thought of only 10,000 years makes it seem like yesterday.

Ten thousand years ago, during the most recent Ice Age, Chestnut Ridge, which lies way up in the hills of the Southtowns, was truly Buffalo waterfront property. Imagine down below, where Buffalo is now, but completely covered in ice so high as to hover over our tallest buildings.

At the same period of time, there were not one, but five gradations to Niagara Falls, each rivaling the other in size and ferocity of flow. In about a thousand years, an extremely short period of time geologically, they gradated back to form the one mighty falls.

There was a Great Lake we've come to name Tonawanda,

(*Opposite:*) Buffalo Harbor Sailing Club's fleet of sailboats race every successive Tuesday and Wednesday throughout summer.

that lay between the Erie and Ontario lakes. The demise recession of Lake Tonawanda helped rush the formation of the singular Niagara Falls by squeezing itself out of existence and rapidly expanding Lake Ontario in the process, becoming today's 27 mile-long Niagara River.

Today the Niagara River moves more water in the span of a minute, in a shorter distance run than any other, begging the question: What makes a river, its water or the land that holds it? If the latter is true, call Niagara a puny river, but if the former is true, with focus on water span per minute, then rank her with the Amazon, Nile and Mississippi as a daunting force.

As the Ice Age retreated, its gnarly tendrils scraped out the deep Finger Lakes. Lake Seneca is so deep, near 700 feet, that the Navy does secret tests in her waters far below. The Great Lakes, however, aren't that deep. But if you took a one foot ruler as the average depth for each of them, Lake Erie would stand out as existing only in the top one inch. Erie is known as a puddle jump, or a sloppy bowl of soup, and because of this, she is also known as the Cemetery of the Great Lakes, with over three hundred years of shipwrecks in her store.

At the mouth of the Niagara, viewing from today's City of Buffalo, your eye reaches west toward Canada, then spans to the south, viewing an ever wide Lake Erie, and then to the cliffs and hills of Southern Erie County. Prior to European settlers, this Buffalo area was inhabited by Senecas and other tribes, including an Iroquois tribe named Ongiara, who the French settlers called Neutrals for their mediating abilities.

Buffalo is known today for its many nationalities and festivals year round linked to multinational ethnic interests, but it seems funny that Buffalo doesn't have much of a current base of French-derived population. This wasn't always the case. Many French lived happily among the Indians in early Buffalo around 1758. It wasn't called Buffalo then, however, but as a locale simply known as Lake Erie. When the British took over Fort Niagara, the French burnt their own little Buffalo town to the ground and dispersed. The British took control of the entire region by 1763 after the French and Indian War.

At the time there was a fellow named "Black Joe" Hodges who set up a log cabin store in 1789 to trade with the local Indians. More European settlers moved in and built up the village that had been burned down. Yet within 20 years more, the village of Buffalo would be burned again, during the War of 1812, almost beyond the hope of ever rebuilding. When the Indians and British came and burned her to the ground, all but two buildings were decimated. The following years saw slow growth, but then things began to speed up ever so quickly.

Prior to 1821, Buffalo was the county seat of Niagara County, which spanned clear up to Fort Niagara. In 1821, Erie County was sliced out of Niagara County and set on its own, retaining Buffalo as its county seat. Federal monies poured in to rebuild by 1825, and the Erie Canal, "Clinton's Great Ditch", was built and made Buffalo the greatest grain port in the world, the veritable bread basket to the west.

Burned to the ground twice, she rose like phoenix from the flames and in 1832, she was a lively town, when the official Charter of the City of Buffalo was enacted. By now Buffalo had its banks and breweries, new manufacturers, the first lumber company on the Great Lakes and scores of other wealthy entrepreneurs. All the while, bustling by its waterfront, there were the ventures of incoming and outgoing shipping magnates.

Buffalo's waterfront remains a hub of commerce,

(Opposite:) The Spirit of Buffalo as viewed from the top of the 1833 Lighthouse.

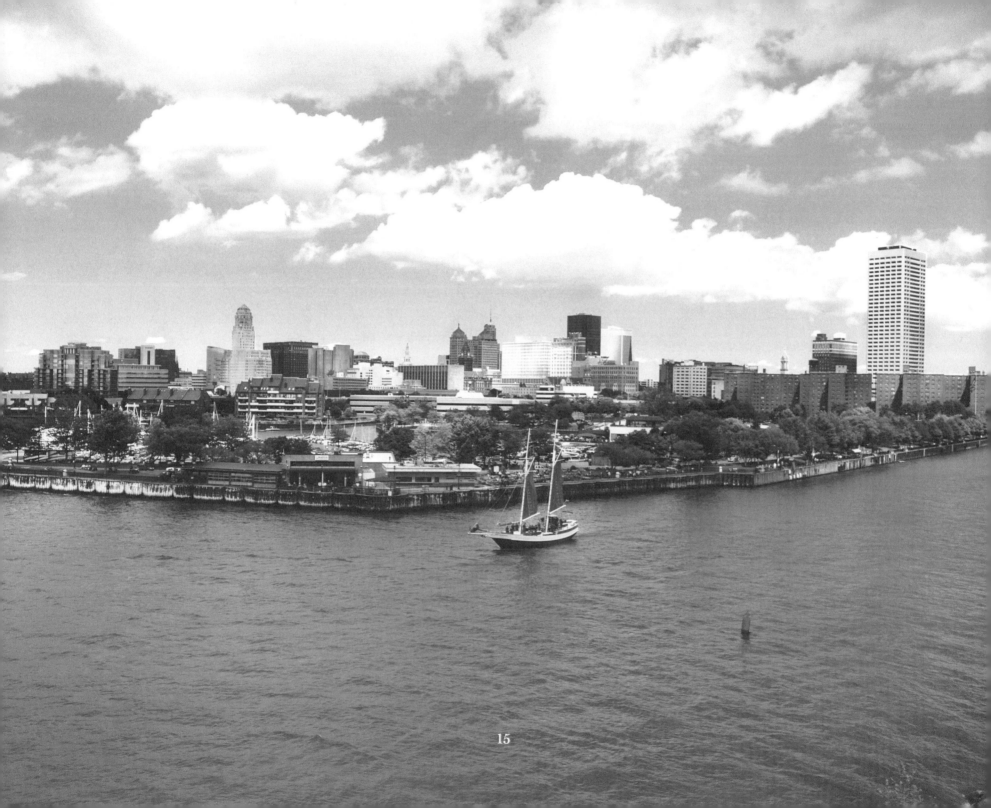

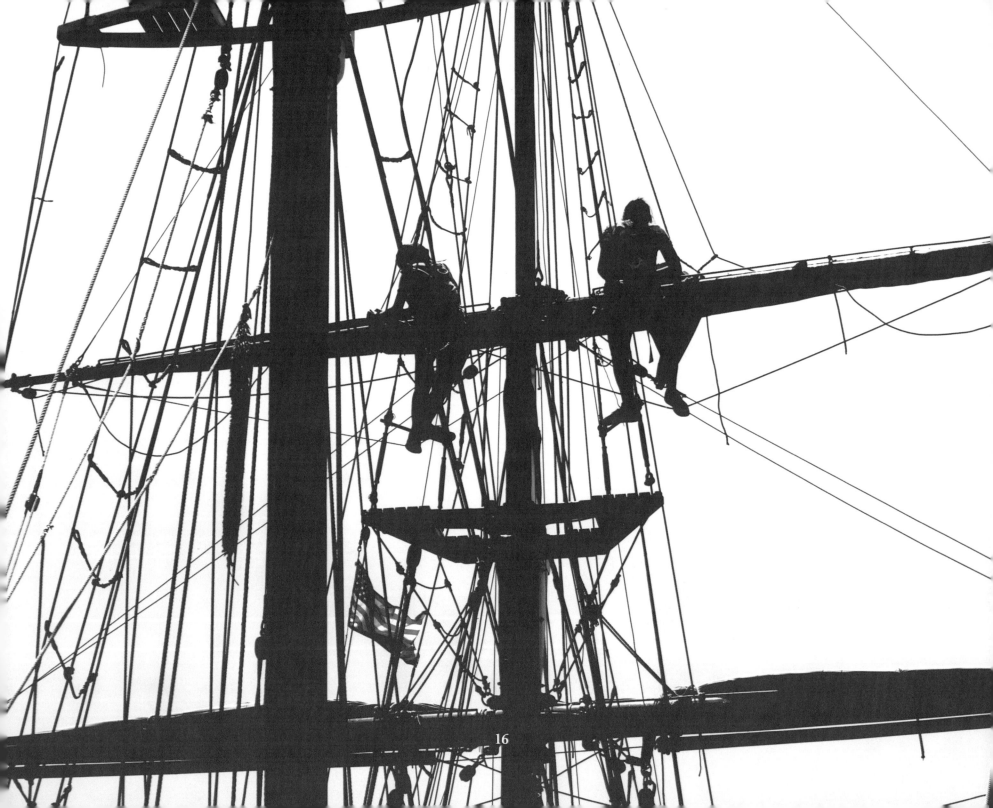

trade, and industry, but her growing importance and accessibility lie in community embracement of her recreational and lifestyle attributes. Today commerce and community share a vibrant and growing waterfront. The people of Buffalo's communities see this as an extension of their city and regional lifestyles, while others invest their hopes in a new Buffalo waterfront as a tourism destination.

With its newly excavated Erie Canal Commercial Slip, built as the original western terminus of the Erie Canal System, revitalization has come to the original Erie Canal Harbor. Visitors stroll along the original stonework that once encompassed stores and shops and warehouses that were placed at the Western Terminus, scenes which are all convincingly coming back to life.

Merging the 19th century historical elements with today's more community and aesthetic perspectives of needs and desires, developers and their historical researchers draw upon elements of the Commercial Slip and Central Wharf that draw upon the sights, scents and soul of days yesteryear when the flow of goods and the bustle of people filled the canal district. Their recreation takes into account the styles and positions of yesteryear's slips, wharves, saloons, warehouses, the various levels of housing and hotels,

manufacturing and distributing facilities, and all along is seen a great backdrop of towering grain elevators.

Buffalo's grain elevators' re-use today has innovators buzzing with ideas, and in fact fascinated people the world over in their day, shown in popular post cards sent all over Europe. Their clean, honest design, construction and materials were based solely on the concept of utility. Le Corbusier saw their futuristic import and coined the term "skyscrapers" after them. Just one of thousands of Buffalo firsts.

We accept that time passes, and needs and opportunities change. Railroads came in the late 19th century, supplanting some of the need for canals. Eventually the Saint Lawrence Seaway arrived and changed the need of Buffalo's industrial waterfront forever. But even as the city itself changed from industrial, automotive and steel focuses to that of science, research, technology, and tourism, the brightening light shows upon our waterways as well as a new dawn for Buffalo and the region.

Buffalo's growing and renowned Medical Campus is considered to be one major bookend to its resurgence, while its waterfront is the other. Together a beaming new light, as if coming from the city's very logo of its Buffalo Lighthouse, seems to shine on the growing hopes, uses and dreams for our waterfront city. A growing new respect reaches near and far for our Queen City on the Lake.

So, cheers, mates, to her grand legacy, and to your future with her, may they both be truly magnificent.

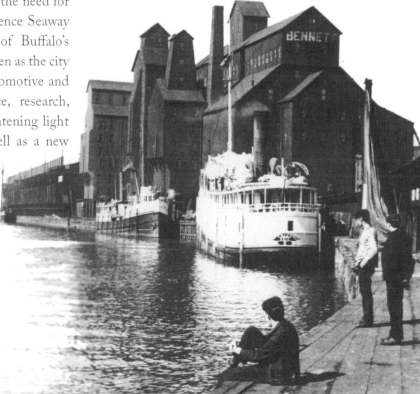

(Opposite:) Crew adjusting the rigging of a tall ship at the **Basil Port of Call: Buffalo**

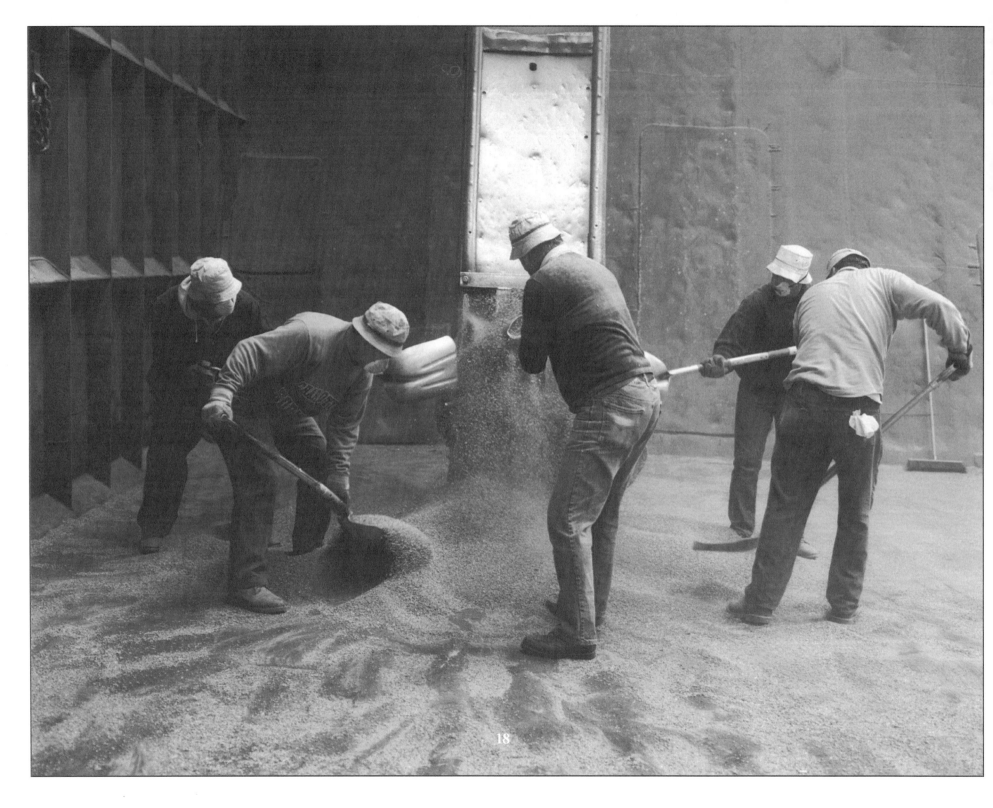

A very old, overnight success

"Give me a couple of years, and I'll make that actress an overnight success."

—Samuel Goldwyn

That actress would be our Queen behind our fair City. Today we see the touring boats and festivals crowding Canalside and all along the waterfront, with construction cranes looming overhead, raising new hotels, and yet to the heretofore naysayer "when are THEY going to do something about our waterfront?", it's apparent the Buffalo waterfront is on the move. The recent decade alone has seen a steady rise of activity, almost at blinding speed, yet it took decades to get here, and suddenly she's becoming an "overnight success."

Another overnight success occurred back in 1825 when Buffalo was the focus of the most demanding engineering projects in the country. The building of the Erie Canal became the principal driver behind Buffalo's explosive growth in the mid-to-late 19th and early 20th centuries.

The advent of the Erie Canal arguably made Buffalo the center of the known universe. It was the crossroads connecting the manufactered products from the east with the rich agricultural bounty of the west. Despite the Canal Terminus's lofty role during its 1860s heyday, the waterfront was the polar opposite of paradise. It was chock full of riots and fun, emancipation and war, booze, brothels, battles, and more, depicting a wild and wondrously wicked, absolutely ruddy hell of a place to romp and hope to survive.

Buffalo brought the world the phrase "what a dive," for this "pub-as-dive" concept comes from Buffalo, where in literal truth, it meant you had to dive down the physical set of stairs at William Douglas' Dug's Dive on Buffalo's Canal. "Dug" was a former Tennessean slave who came determined to conduct business in the Canal marketplace in the mid-1860s. While it is not known if he

(Opposite:) Buffalo's grain scoopers emptying ships

escaped from slavery or was freed, once in Buffalo he became an independent business-man whose customers were mostly African-American sailors, canal boatmen, and dock laborers.

His was one out of hundreds of saloons, boarding houses, and brothels near the docks that offered drinks and food, entertainment, and physical companionship to those who came to the Port of Buffalo. "Dug" was unique, known as a good Samaritan for giving food and a place to sleep to African-Americans in need of help.

Fugitive slaves likely found refuge in Dug's

Dive as a probable Underground Railroad site, along with other establishments in the Union Block, also known as "Negro Block." Finding safe refuge meant a life or death struggle in Buffalo's African American community during the 1850s and 1860s.

The Fugitive Slave Act of 1850 (passed under the Administration of Buffalonian Millard Fillmore) meant that long-settled blacks up north faced the possibility that they could be reintroduced to slavery, with the added threat that any person helping them could be criminally implicated as well. Runaway slaves who worked on boats traveling the Great Lakes were at particular risk, never knowing what

authority might be waiting on shore at any port of call.

Today, another major engineering environment project is underway involving the Buffalo River cleanup. Change and progress isn't all glitter and lights, and some progress is of the unseen type, infrastructural and environmental work that needs to be done.

More than a century's worth of pollution and ecological abuse got the better of our Buffalo River, such that today's project is the Buffalo River Sediment Remediation Project, which is underway on a $40M task order to clean up the Buffalo River and the City Ship Canal. This Sediment Remediation Project involves dredging over 400,000 cubic yards of sediment contaminated with PCBs, then disposing of it in a confined disposal facility or an offsite TSCA-licensed landfill, followed by capping of nearly 10 acres of contaminated sediments. The pollution didn't occur overnight; in fact, it's said that back in 1925, even bacteria couldn't live in the Buffalo River!

Buffalo's river and waterfront became home to countless "heavy-manufacturers" that produced cement, copper, steel, and other essential materials that fueled the rapid growth of America.

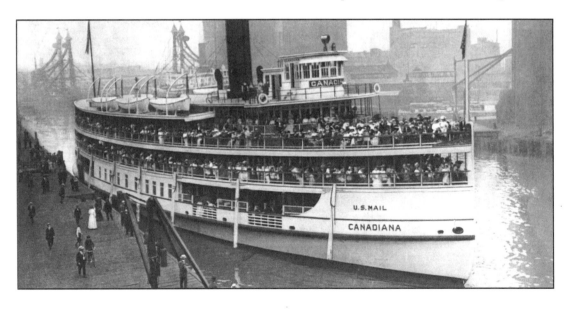

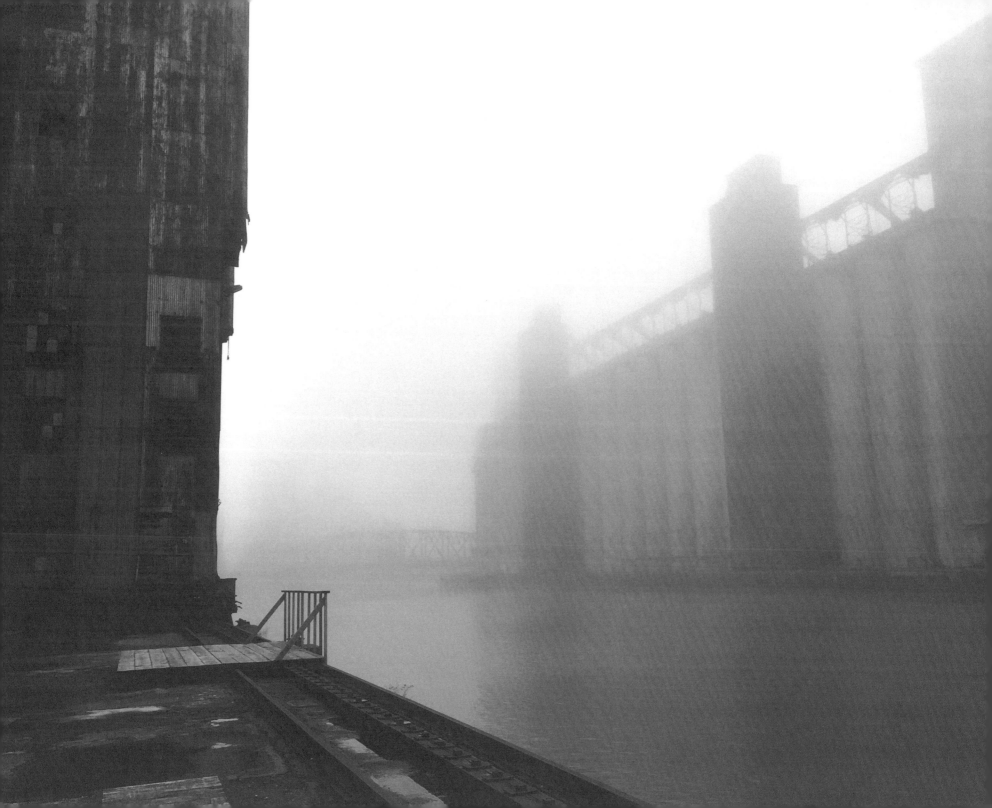

Because of this growth, Buffalo transformed from a frontier village into a thriving commercial and industrial metropolis at the onset of the Erie Canal. The Canal established an all-water passage from the Great Lakes through Buffalo to the port of New York and the world.

You might say that time of growth was our first spell at overnight success, as Buffalo grew as the portal of transshipment to and from the American Midwest, transferring goods and passengers between canal boats and lake ships. And at the eastern end, New York City grew to become the continent's financial and commercial center.

As to the fun and excitement and development that is and will increasingly be for our waterfront, know that it took decades to inch-worm its way before currently speeding up and all along had its concerns of the environmental type to deal with. We won't be through the woods until we clean up the rivers.

As the decades passed, there came waterfront "spurts" of action now and again, most notably from the understated but ever worthy efforts to fund and enhance our waterfront by Congressman "Billion Dollar Hank" Nowak. But for the most part, most political authority represented on the subject of our waterfront seemed to have had a trickle-down,

disconnected effect among the community.

Real action seemed as stagnated as the water itself. New York Times reporter Denny Lee wrote in 2004, "The lake, after all, is where the Rust Belt meets the water."

Years went by, and a generation saw very little occurring to better our waterfront. That is, until a young assemblyman, Brian Higgins, came to the stage of discourse and grassroots action. Brian had a way about him that smacked "of the people". Sure, all politicians sell that concept, but you really had the feeling Brian meant it. As soon as he was elected to the New York State Assembly in November 1998, he set about creating projects to revitalize the dilapidated Buffalo waterfront.

Assemblyman Higgins worked with governmental partners on the federal, state, and local levels – Democrats and Republicans alike – and secured nearly $20 million in state funding to revitalize lands then controlled by the Niagara Frontier Transportation Authority, including the area known as "Gallagher Beach." Brian later led the effort to create a new state park along the Outer Harbor on the beach site.

At about this time, an all-Saturday waterfront conference was held at

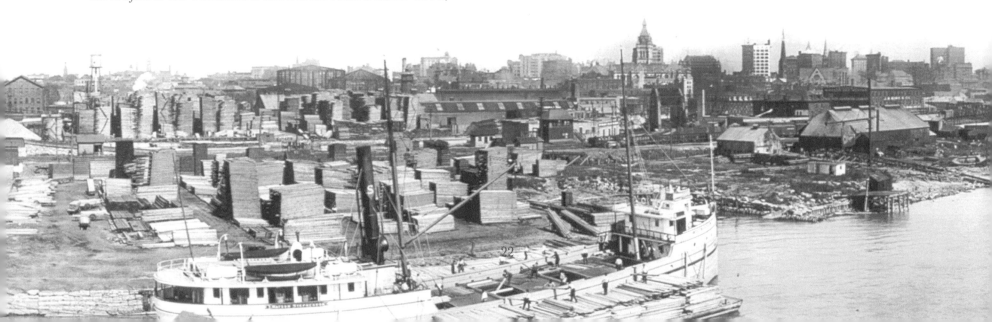

Buffalo's Statler building, featuring representatives from the state who took turns reading off lists of millions of dollars being spent regionally and throughout the Great Lakes on water quality and the like. Brian Higgins, the main guest speaker, took the microphone and walked among the audience in shirt sleeves, vigorously speaking about community and government working together to make change. He had just recreated Gallagher Beach, so his words had the benefit of proven results. He implored the audience to believe in their voice and to give it a chance to collectively take over our waterfront.

Other individuals, factors, administrators, and community support groups have come to bear efforts in and administration for a revitalized waterfront in the years that followed. At the forefront of this leadership and manager of the majority of its funding is the Erie Canal Harbor Development Corporation. The ECHDC was formed as a subsidiary agency of Empire State Development with the vision to "revitalize Western New York's waterfront and restore economic growth to Buffalo."

Because it is vast in power and influence, this is a decidedly different era of social media influence, and seemingly at every turn, the ECHDC

reaches out to listen and appeal to community voices to make changes that come from the voice of all concerned.

Voice Buffalo is one group they listened to. The ECHDC staff and board also meet regularly with the Buffalo Waterfront Working Group, founded by Buffalo Lighthouse Keeper Mike Vogel and comprised of mainly commercial and non-profit stakeholders along the waterfront. The ECHDC staff also talks and listens to Mark and Tony Goldman and other community advocates who are members of the Canal Side Community Alliance to discuss the "things" their community wants to see built.

From groups of authority to groups of support, the list is long but also includes some brave pioneers who often seemed to stand alone against the winds and tides of time. One such waterfront hero was Captain Harvey Holzworth. Until he passed away a few years ago, this octogenarian could be seen at nearly every waterfront conference, meeting or affair. With back bent over, the tireless, elderly captain was a veritable social media machine all to himself as he entered a room with cane in one hand and a suitcase full of treasured waterfront history photos in the other.

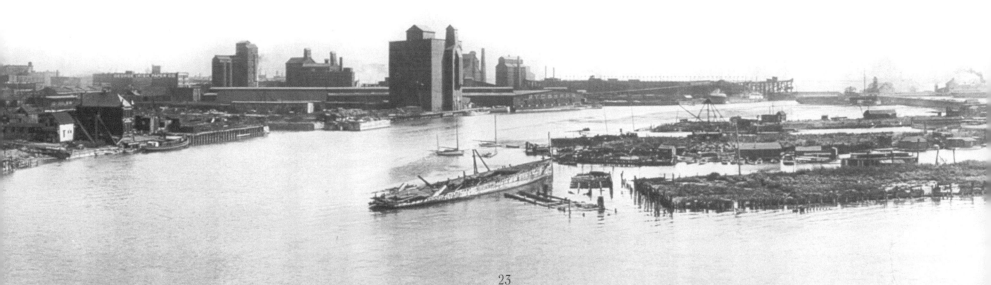

Around his neck hung a voice box simulator microphone he would apply to his larynx to speak from, and many will recall that when he stood to speak, he became the force of the event. Captain Holzworth was a lake salvage boat services entrepreneur, but he was many things in his long life, including community activist, photographer, and waterfront historian, for starters. Holzworth was the very last Captain of the Canadiana and the very first Harbor Master of Erie Basin Marina. The historic SS Canadiana was a famous passenger ferry that operated between Buffalo and the Crystal Beach Amusement Park at Crystal Beach in Canada from 1910 to 1956. The Canadiana was also noted for being the last passenger vessel built in Buffalo, New York.

Many of today's older Buffalonians remember their first romances and dances on board the gloriously designed 215-foot Canadiana. She was fitted with brass railings, red mahogany trim from Honduras and beveled mirrors. She was designed to be a premier vessel intended not only for transportation but also for pleasure, able to carry 1800 passengers. She was built with the largest dance floor of any steamer ever placed on the Great Lakes.

Harvey Holzworth was a historical restoration pioneer in an era that seemed too often to let things of value fall asunder to decay and demolition. He knew the value of efforts taking decades before becoming an overnight success and invested his time and monies for years attempting to salvage and restore the Canadiana after her dry-docking and years of decay.

In his last years, Harvey Holzworth was able to salvage and transport back to Buffalo the remnants of its great engine, with hopes to one day power it on display for waterfront visitors to learn from and enjoy. Against the odds of weather and decay and lack of support interest, he was determined to salvage the historic ship's pilothouse, saving much of the wooden superstructure, while some of the other salvaged wood has been manufactured into various pieces of memorabilia.

Cheers to the dreamers, pioneers, stalwarts, and visionaries of Buffalo's past and present. Cheers to the stubborn and determined. Cheers to the disruptors like historical preservationist Tim Tielman. He used his organizational skills to slow-walk Canalside progress until it would be done right, with a sensitivity to its unique history.

Cheers to every new young voice that raises it on social media and at public meetings to speak out and have their say on what is right for our waterfront.

And Cheers to You; may your waterfront dreams be fulfilled.

25

26

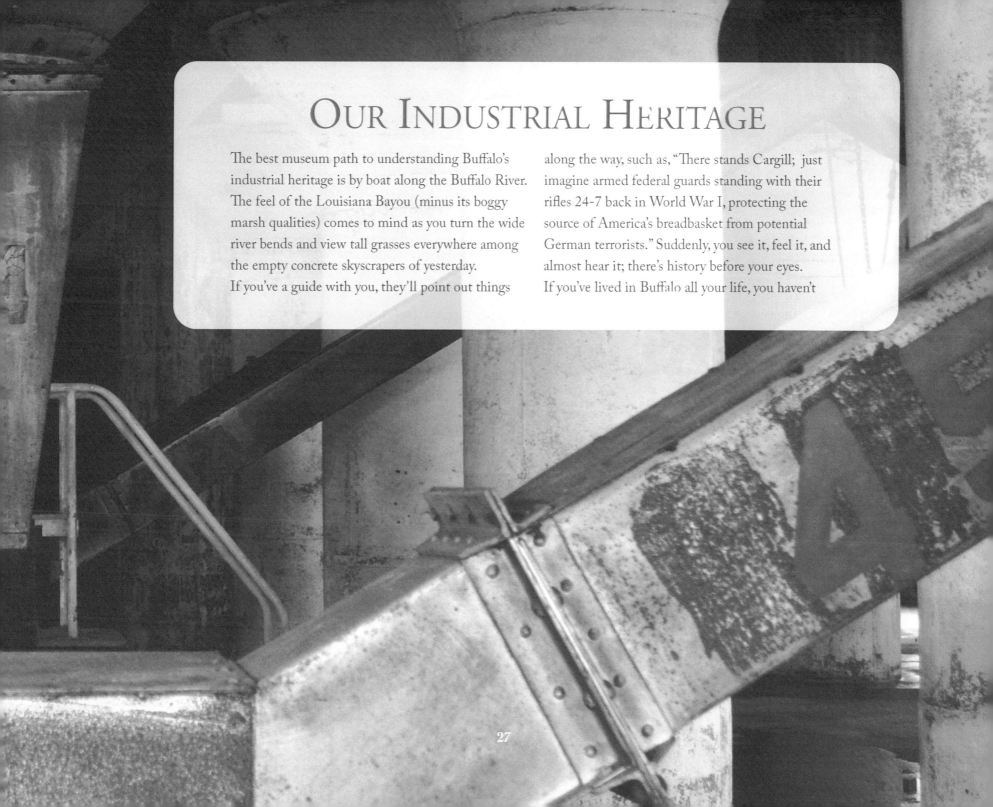

OUR INDUSTRIAL HERITAGE

The best museum path to understanding Buffalo's industrial heritage is by boat along the Buffalo River. The feel of the Louisiana Bayou (minus its boggy marsh qualities) comes to mind as you turn the wide river bends and view tall grasses everywhere among the empty concrete skyscrapers of yesterday.

If you've a guide with you, they'll point out things along the way, such as, "There stands Cargill; just imagine armed federal guards standing with their rifles 24-7 back in World War I, protecting the source of America's breadbasket from potential German terrorists." Suddenly, you see it, feel it, and almost hear it; there's history before your eyes.

If you've lived in Buffalo all your life, you haven't

seen its true expanse or singularity by car because it's set far back in. Nor by sailboat, for the masts can't go under the low bridges. Touring the grain elevators around Kelly's Island requires navigating by a low boat or a kayak, and the memory experience stays with you, hinting that you never knew Buffalo held such a stunning, silent surrounding full of heritage and haunted by ghosts of its industrial legacy.

Commercial grain handling started in Buffalo in 1827, after the opening of the Erie Canal, and lasted well into the time of the Second World War, only diminished after the opening of the Welland Canal, which offered new methods of transshipment of goods and grain.

Today, the grain industry still thrives in Buffalo plants dedicated to milling rather than on transshipment. General Mills is one of the last working grain elevators in Buffalo standing sentry at a complex that sprawls over 27 acres bordered by the Buffalo River and the City Ship Canal. There they produce well-known cereal brands such as Cheerios, Lucky Charms, Honey Nut Cheerios and Total cereal, as well

as Gold Medal flour.

Often when you roam downtown streets or have your car window open, you can smell the sweet Cheery-Oat product being roasted. They take an oat flour base, mix it into a dough, then cook it and push it through an extruder. The product "pops" in the cooking process, just like corn, and that makes them a Cheerio. Some days, there's a chocolate twist to the smell in the air, attributed to making Count Chocula.

General Mills stands among the few active mills left. A revitalized Buffalo, however, offers hope of new monies and visions to give re-use to many of those monolithic concrete structures standing empty along the river's edge, as if waiting for lake freighters to come that never will again. At one time, they stood tall as a symbol of Buffalo's prominence as the largest grain supplier in the world.

The revolutionary arrival of the Erie Canal allowed grain to be shipped to New York and the Appalachians and made the freight charges drop from $100 to $10 a ton for grain shipment. The problem was getting the grain from

large lake freighters onto small narrow boats that could traverse the narrow canal. This meant a slow and arduous work detail for the many Irish who labored there and caused delays and people congestion along the waterways.

In 1830 the mostly Irish immigrants handled 146,000 bushels of grain at Buffalo. Within ten years, the amount was ten times as great. It took five hundred men to unload or load this amount of grain by hand. Grain dust was explosive as well as suffocating to the men involved. And it was still slow.

Grain traffic volume rose from 112,000 to over 2 million bushels between 1835 and 1841, all literally loaded on the backs of men. Joseph Dart saw the need for a faster and more efficient method of loading and unloading grain from the ships that arrived in Buffalo, and in 1842, he constructed what came to be known as the first grain "elevator" at the foot of Commercial Street on the Buffalo Creek.

Dart's invention comprised a wooden structure that served as storage bins for the grain, loaded in by a steam-driven belt with

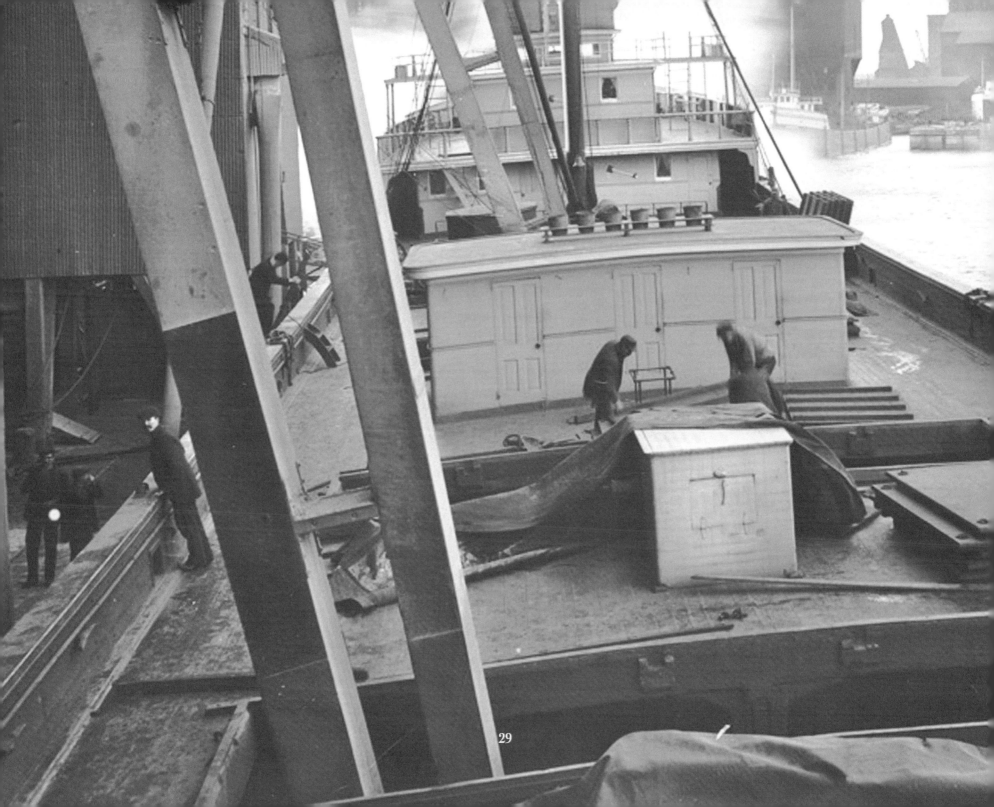

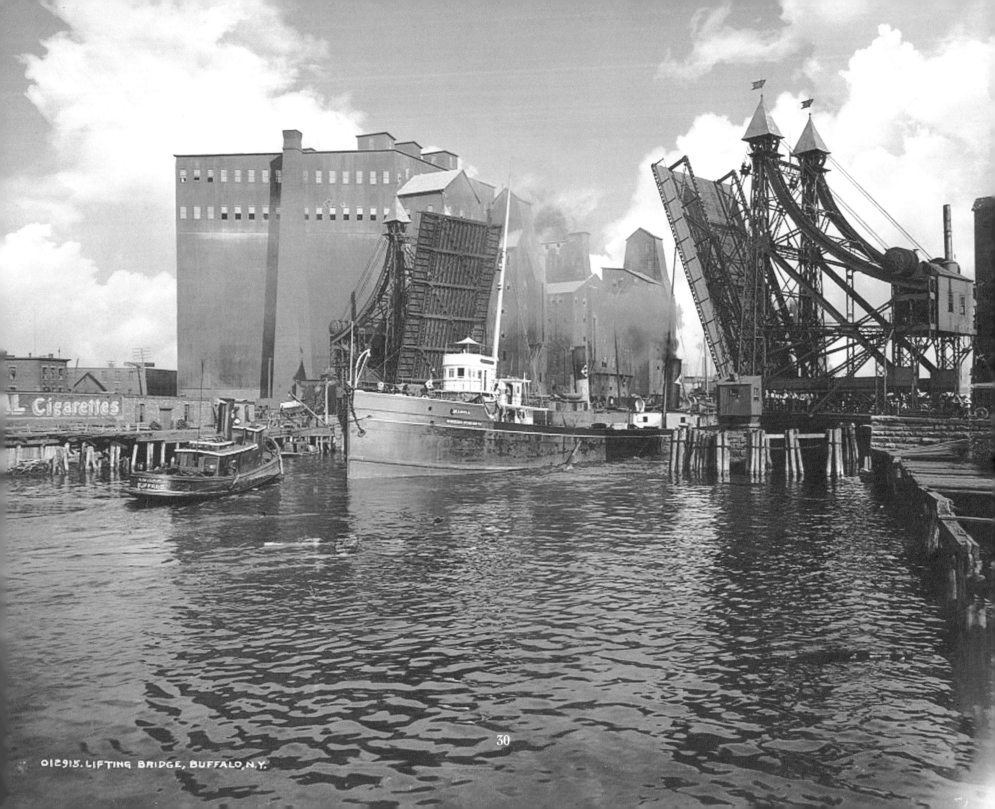

30

012915. LIFTING BRIDGE, BUFFALO, N.Y.

buckets attached. The buckets were lowered into the ship's hold to scoop up the grain and hoisted into tall wooden bins. This is where the term "elevator" originated because this is exactly what the process did.

Dart wasn't even a grain man, but a Main Street merchant who came out of his league and took the industry by surprise—rather like an inventive upstart today turning Silicon Valley on its head. Dart's first elevator had a capacity of 55,000 bushels of grain, and three years later, this was doubled. Still, he had critics, most notably a competitor by the name Mahlon King.

Mr. King visited Dart's operation, walked about, and scoffed: "Dart, I feel sorry for you. I have been through that mill and it just won't do. Remember what I say: Irish backs are the cheapest elevators ever built." One day, King would return with his head low saying, "Dart, I find I did not know it all."

As Dart's grain elevator came into its own, it allowed ships to be unloaded at the rate of over 1,000 bushels per hour. Dart's grain elevators however were made of wood, and the explosive grain dust could trigger fires that would spread to other elevators close by.

Eventually, elevators were made of steel and brick, which curbed the fire aspect to a good deal and allowed the new opportunity of electricity to operate the plants.
Soon the mills were made of concrete and were popping up all over the harbor, which led a visiting Le Corbusier to call them "sky scrapers," and postcards showing their designs fascinated people from all over Europe. As decades passed, railroads came to be and fed even more business to the mill industry. Animal feed mills became a large addition to grain milling as well.

But after the Second World War, things would change dramatically. The Welland Canal was a huge blow, and the final blow was dealt in 1959 with the opening of the St. Lawrence Seaway, which gave moderate size ocean vessels passage into the interior of North America by way of the Great Lakes. Buffalo was cut off completely in the supply chain, with no longer a need to dock at Buffalo to load or unload grain. At one time, thousands of men and women were unemployed one way or another with the grain industry. Now their jobs were gone for good.

By all means, take a boat tour of the mills with an experienced guide, and learn more about

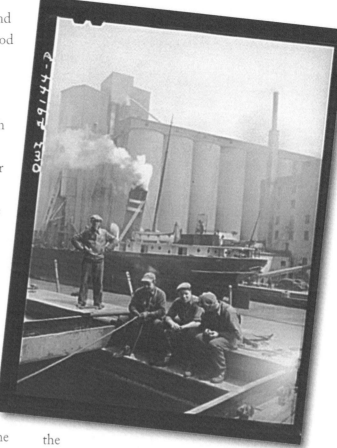

the technology, history, architecture, and peoples behind its industrial past, all while enjoying the natural scenery that abounds. Learn too about the many innovations for re-use being developed for other grain mills around the world. Whether we should be thankful they still stand because of lack of demolition funds or insight, they do still stand, ready for transformations into a new age.

(Opposite:) Michigan Avenue Lifting bridge, circa 1900
Detroit Publishing Company photograph collection (Library of Congress)

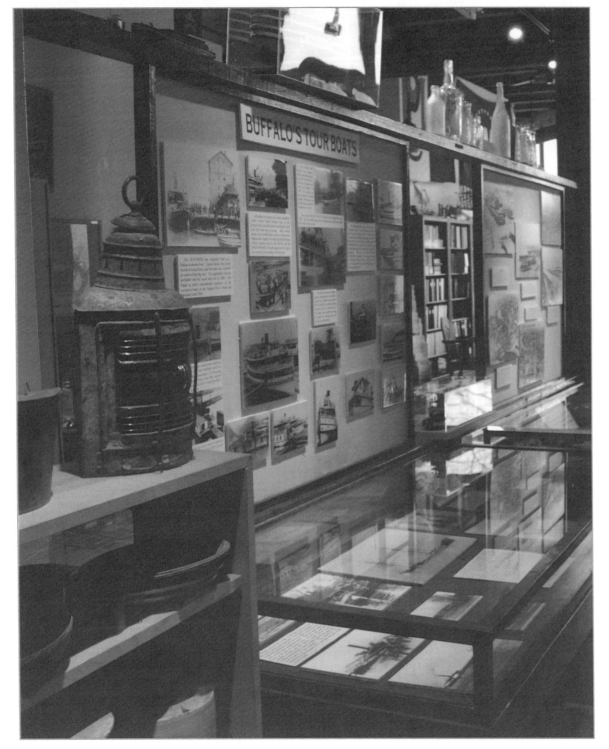

The Buffalo Harbor Museum

The Buffalo Harbor Museum, formerly the Lower Lakes Marine Historical Society, has an aura about it that loves and respects the history of the maritime kind. Even its classically stone-carved building has a historical mystique. Once the Howard H. Baker Ship Chandlery in the Old Harbor District, ships would come into port daily needing to stock up and refresh or replace inventories for their lake journey.

A chandlery like Baker's supplied all the ships, canal boats, and lake freighters with supplies that included necessary foodstuffs, ship's wiring, ropes, and lines – pretty much anything they needed when in the 19th and 20th century Buffalo was the third largest inland port in the world.

The Buffalo Harbor Museum's founders and volunteer staff are dedicated to collecting, acquiring, preserving, and exhibiting of memorabilia relating to the marine and maritime history of the Port of Buffalo. They maintain an open-to-the-public museum and library in addition to its daily drive to acquire, assess and chronicle manuscripts and logs, charts, and replicas of lake history and, in particular, Buffalo's port history.

(Opposite and Right) Built in 1896, the museum houses an extensive collection of maritime history with displays and exhibits that contain archival photos and artifacts that illustrate the transformation of Buffalo's waterfront in the early 1800s.

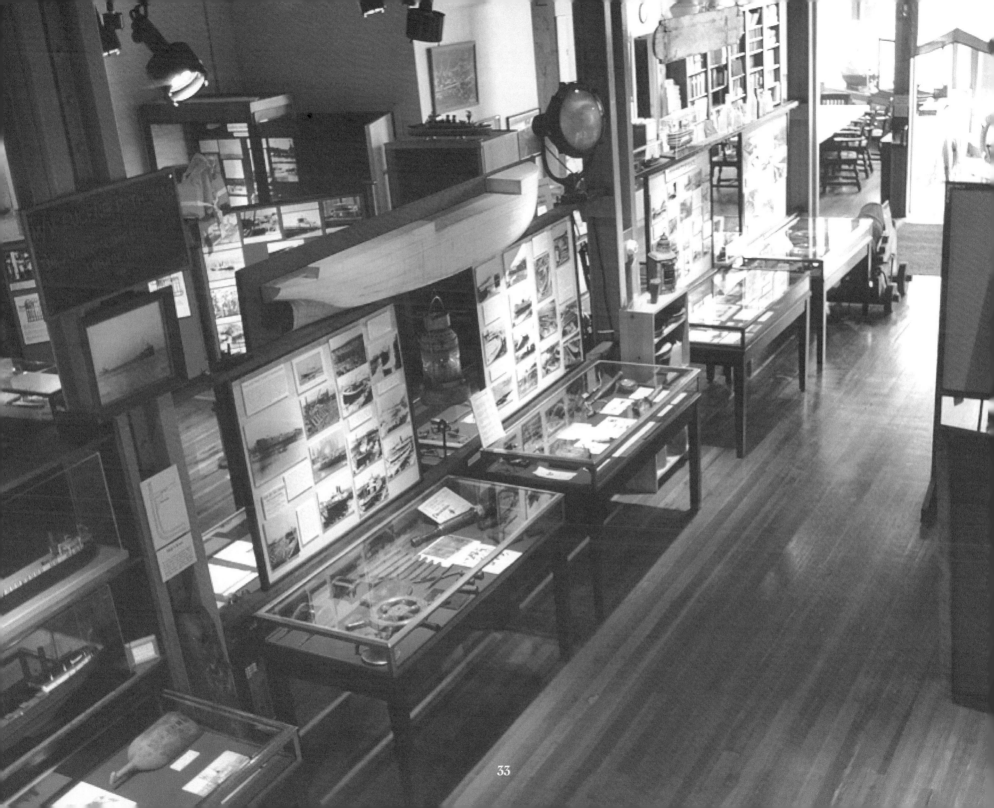

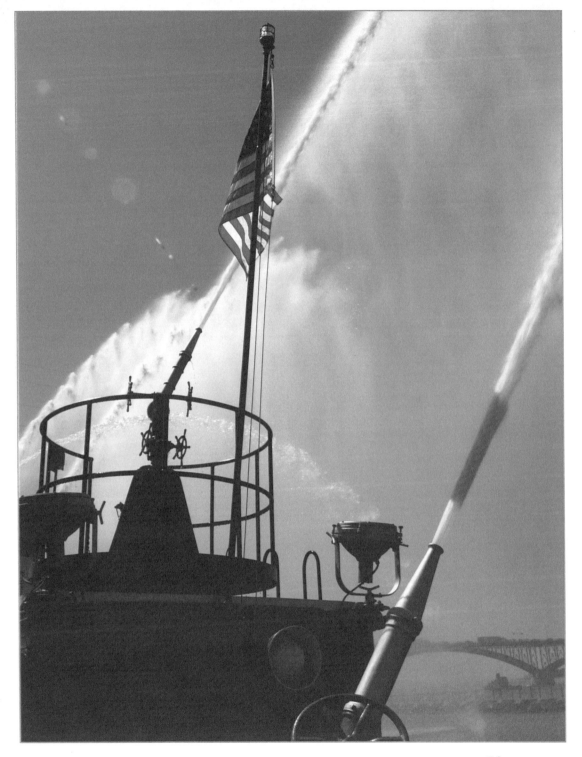

Fireboat Edward M. Cotter

More than a century after her construction, the fireboat Edward M. Cotter is a proud symbol to our city.

She was built in 1900, during Buffalo's booming harbor era, three years before Orville and Wilbur Wright made their historic flight at Kitty Hawk. The Cotter not only protected grain elevators in times of fire crisis but is also the sole ice breaker of Buffalo's waters to this day. The 1.5 inch thick belt line of Swedish steel around the hull allows her to cut through the thick ice that forms and piles up in the Buffalo River and Outer Harbor.

The Cotter mounts five fire monitors capable of pumping 15,000 US gallons per minute. She can often be seen sailing out from her berth to Lake Erie, then returning north through the break wall and firing her fire monitors.

At age 60, when most boats would consider retirement, the Cotter was called into active duty. On October 7, 1960 she crossed international lines into Canada to aid in the suppression of grain elevator fires in Port Colburn. Their local fire department did not have a fireboat and was unable to bring the fire under control. Escorted by a United States Coast Guard cutter, they traveled for two hours to the scene and helped control the fire within four hours.

In 1996 the Edward M. Cotter was designated a National Historic Landmark.

Along with her regular duties, as Buffalo's waterfront ambassador and head cheerleader, you'll always see the Edward M. Cotter at events and ceremonies around the Great Lakes.

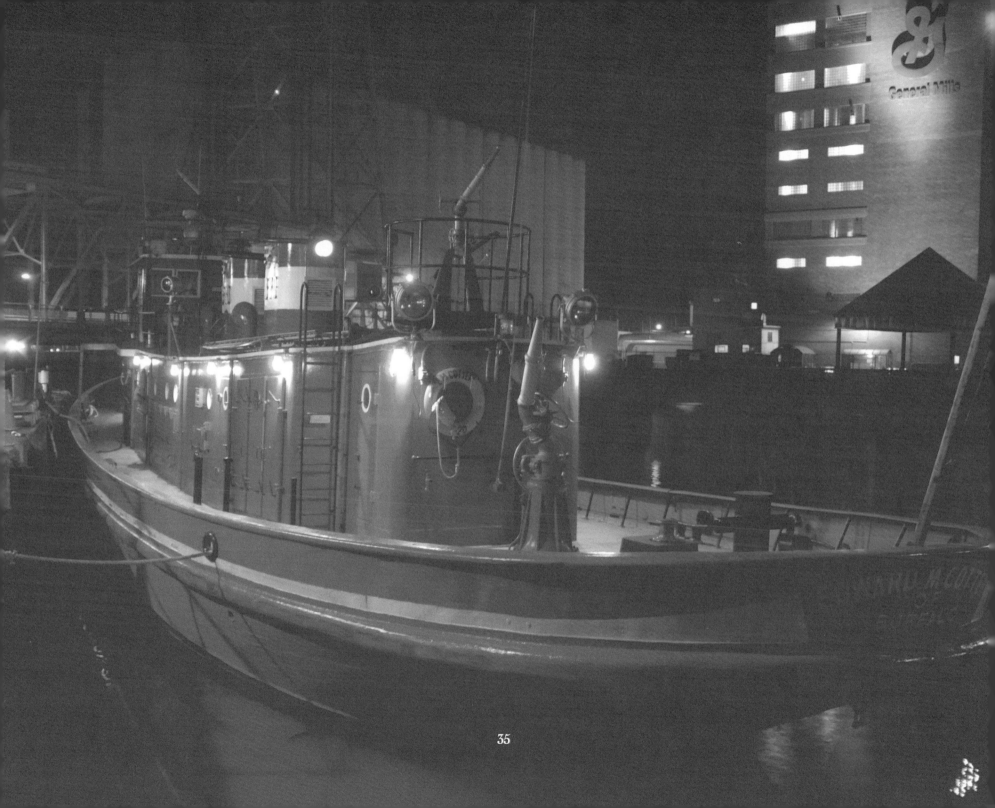

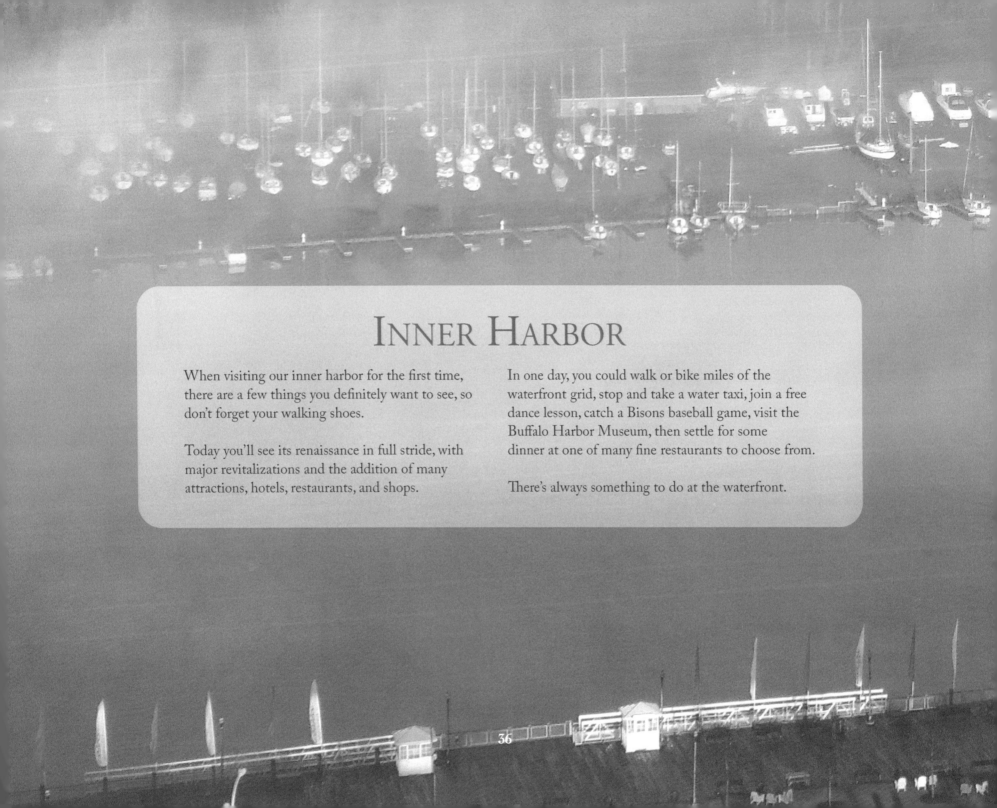

INNER HARBOR

When visiting our inner harbor for the first time, there are a few things you definitely want to see, so don't forget your walking shoes.

Today you'll see its renaissance in full stride, with major revitalizations and the addition of many attractions, hotels, restaurants, and shops.

In one day, you could walk or bike miles of the waterfront grid, stop and take a water taxi, join a free dance lesson, catch a Bisons baseball game, visit the Buffalo Harbor Museum, then settle for some dinner at one of many fine restaurants to choose from.

There's always something to do at the waterfront.

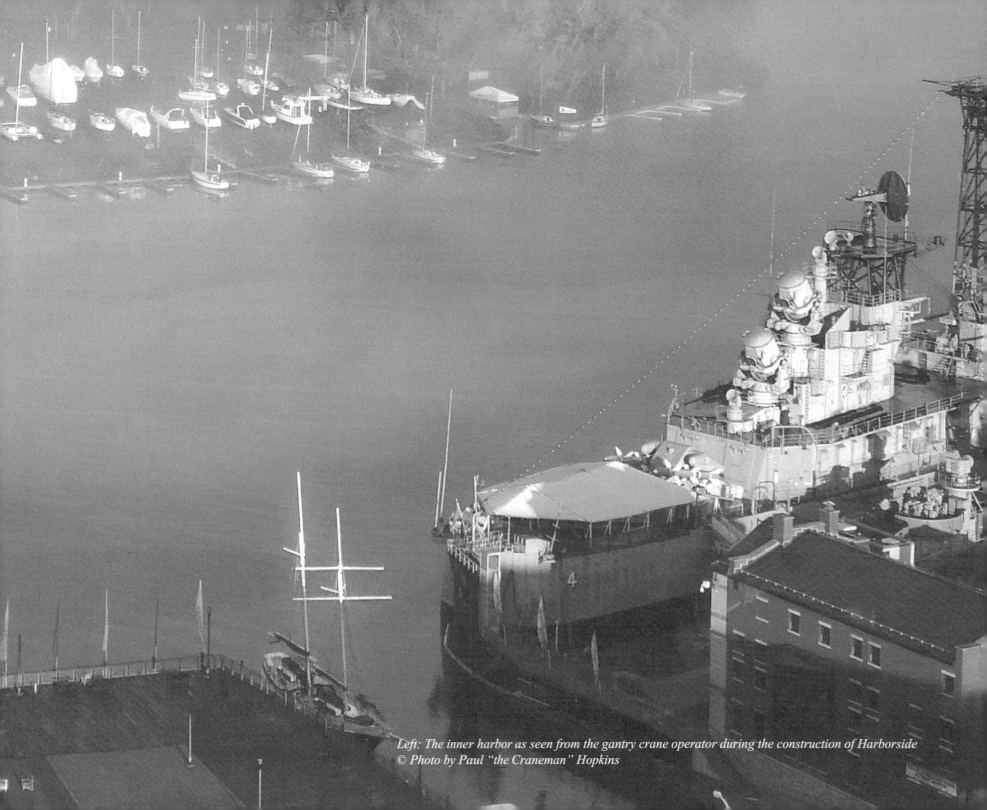

Left: The inner harbor as seen from the gantry crane operator during the construction of Harborside
© *Photo by Paul "the Craneman" Hopkins*

Erie Basin Marina

It's easy to forget that the Erie Basin Marina, one of the most popular places on the Buffalo waterfront, was once just a breakwater and commercial slip at the mouth of the Buffalo River at Lake Erie. Not even connected to the mainland, its purpose was to lessen the impact of storm surges. In 1970-1973 a major lakefront improvement project constructed the road, walkways, marina, tower, and buildings. Hidden to all but birds, airline pilots, and people viewing it from the City Hall observation deck is the fact that the marina was designed in the shape of a buffalo.

Today Erie Basin Marina is so much more than a giant parking lot for boats. It is actually a neighborhood, complete with offices, condos, and restaurants.

Visitors come to watch sailboats skim gracefully past the historic lighthouse while being surrounded by fabulous professionally groomed gardens. They can build an appetite as they scale the 83 steps of the Outlook Tower for the best panoramic views of the city and then enjoy comfort food, ice cream, and occasionally good Karaoke at The Hatch restaurant. Many just come for their daily stroll or sit and observe the fantastic sunsets that glimmer across the lake.

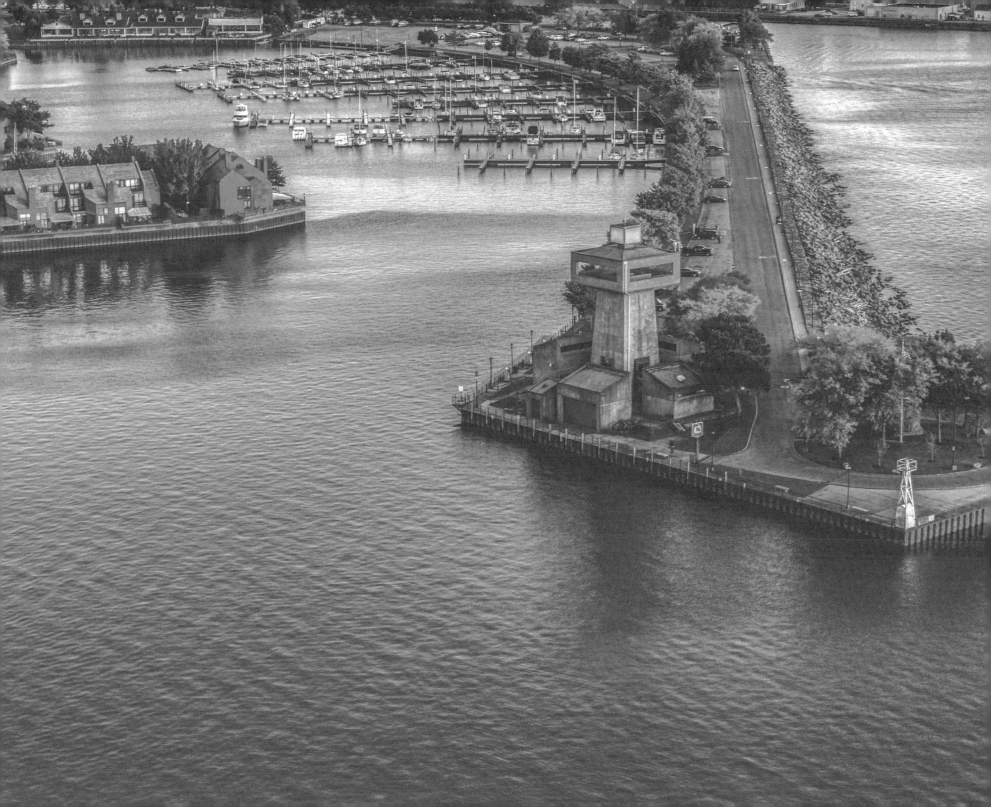

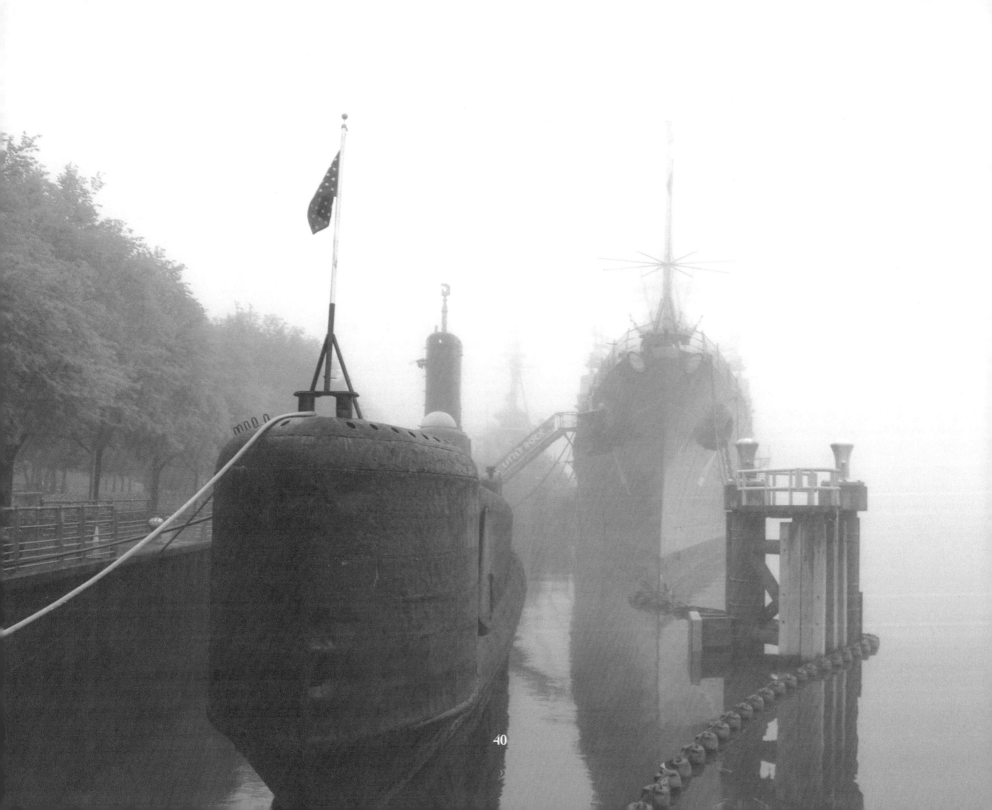

Buffalo Niagara Naval Park

Adjacent to Buffalo's Canalside, you'll see an expanse of the largest inland naval and military museum park displays in the country, called the Buffalo and Erie County Naval & Military Park. Public tours to the park give the opportunity to view several decommissioned U.S. Naval vessels that include the Cleveland-class guided-missile cruiser USS Little Rock, the Fletcher-class destroyer USS The Sullivans, and the submarine USS Croaker.

Once within the park, you'll see blades, once powered by a Porsche engine, sitting peacefully on a U.S. Marine Corps helicopter. Nearby, a World War II seafaring destroyer with nine battle stars to its name takes its place among tanks such as the 22.3-ton tank that served in the Korean Conflict.

The park's curators have amassed many such machines designed for (and are themselves veterans of) combat. Numerous exhibits feature historic relics, such as the only guided-missile cruiser on display in America.

Construction and acquisitions started in 1977, and opened to the public on July 4, 1979. In 2003 the ships were moved slightly to the foot of Pearl and Main streets, a major engineering feat in itself. The Naval Park now abuts the historic Commercial Slip at Canalside.

The Naval & Military Park is a real treat for all history enthusiasts. Besides the exhibitions themselves, the building also has a souvenir shop and a huge hangar with an adjacent area displaying U.S. marine vehicles.

Families and individuals touring the park are offered plentiful educational and interesting facts pertaining to the history of wars. These include the opportunity to roam deep within the ships and to actually experience how mariners and submariners lived and carried out their patriotic duties to their nation.

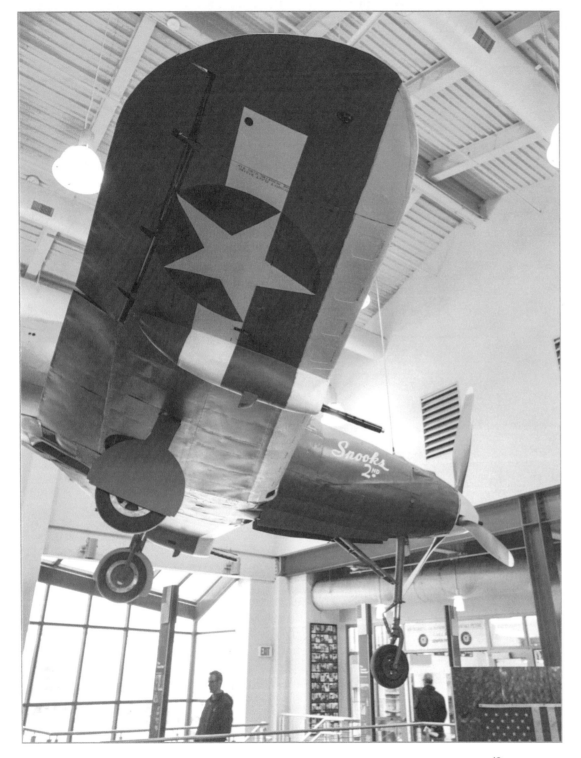

USS The Sullivans

The Buffalo Naval Park's decommissioned Fletcher-class Destroyer, DD-537, was the largest and most important class of U.S. Destroyers used in World War II. USS The Sullivans, named after the five brothers from Waterloo, Iowa, was the only Navy ship to be named after more than one person. She was commissioned in 1943 and saw action in the Pacific Theater, the Korean War, and the Cuban Missile Crisis. USS The Sullivans was decommissioned in 1965.

USS Little Rock

The USS Little Rock CL-92 (CLG-4) is the only surviving vessel from the Cleveland Class of light cruisers in World War II and is the only Guided Missile Cruiser on display in the world. CLG-4 is the largest of our vessels here at the Buffalo Naval Park.

USS Croaker SS-246

Representing the U.S. Navy's "silent service", The USS Croaker is one of 77 Gato class submarines constructed, making her part of WWII's most lethal submarine class. After WWII, she was converted to a "hunter-killer" submarine with added sonar, radar, and quieting capabilities to combat the Russian threat during the Cold War. She was decommissioned in 1971.

P-39 Airacobra *(left:)*

Hanging from the ceiling is a P-39 Airacobra, one of 9,500 built at Bell Aircraft in Buffalo and Niagara Falls. The aircraft was noted for a revolutionary aircraft design in which the armament was given priority over speed and maneuverability. This resulted in the Airacobra being the only WWII aircraft with the engine behind the pilot to accommodate the 37 MM cannon in the nose.

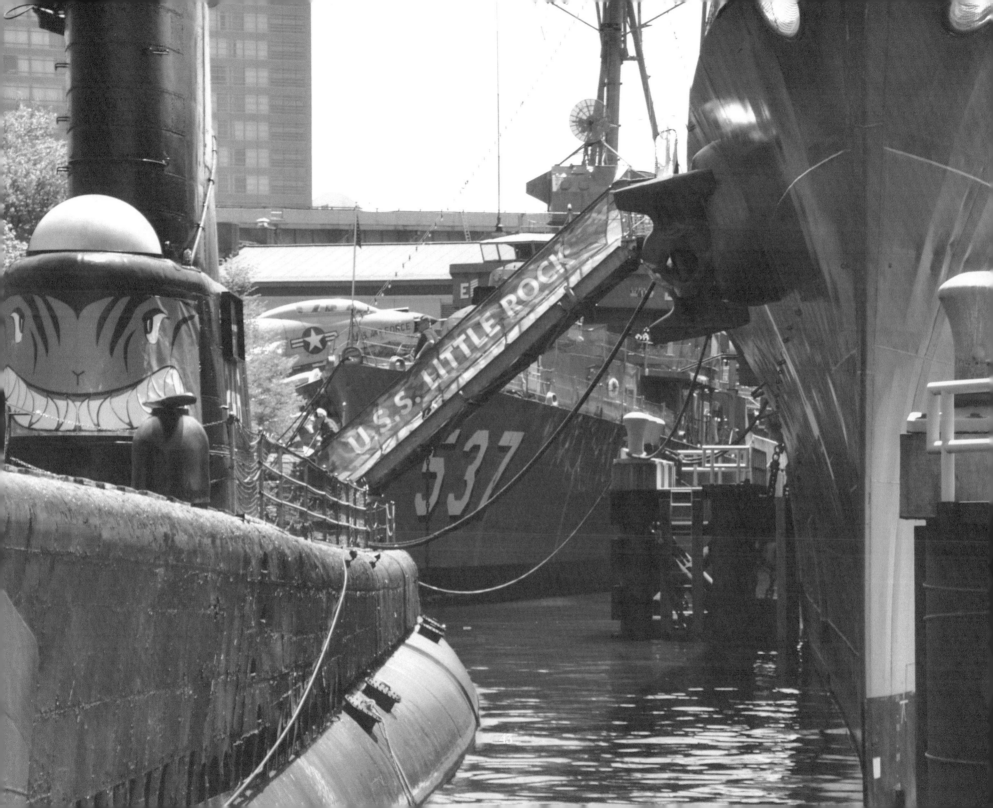

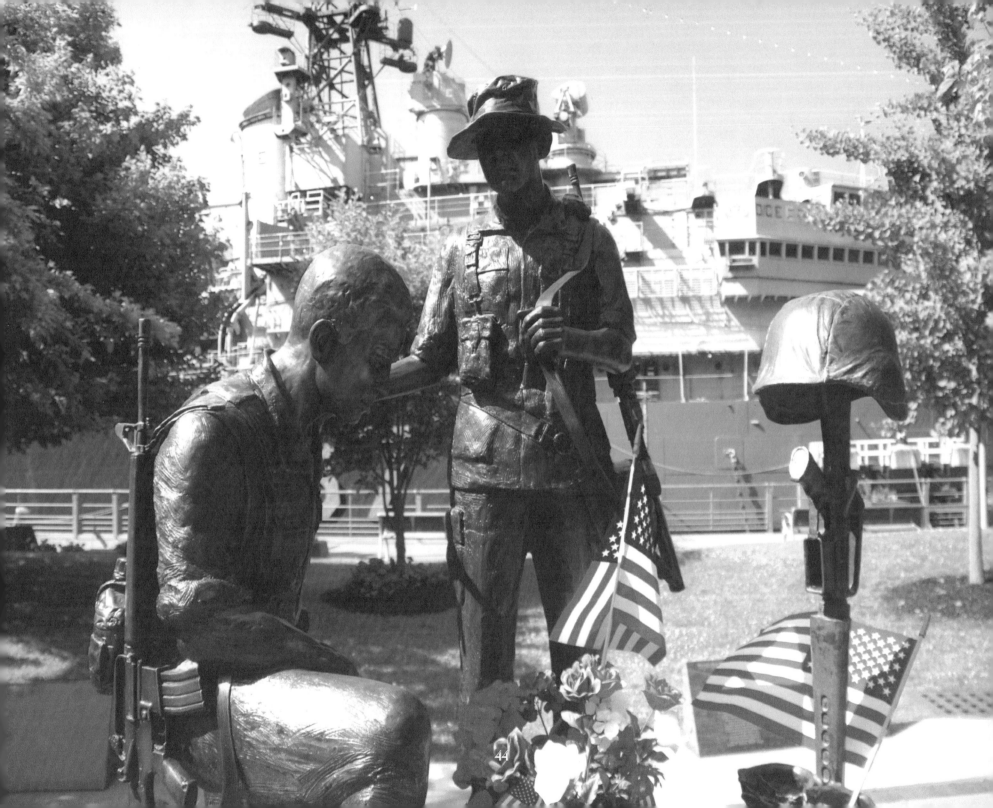

Heroes Walk

The historic war memorials at the Buffalo & Erie County Naval & Military Park's Monuments Garden honors several lifetimes of service in the U.S. Armed Forces. In addition to educating the public with its artifacts, their mission includes honoring and remembering veterans. One of the ways they strive to do this is through our Monuments Garden.

Located in a green oasis along the waterfront, the Monuments Garden is home to many monuments. They include the Iraq-Afghanistan Monument, Vietnam Memorial, Purple Heart Memorial, The Battle Within PTSD Monument, and Hispanic and Latino Memorial. Soon to be constructed is a Memorial to African Americans who served in every conflict in our country's history. This space can serve as a quiet place for remembrance and reflection before or after touring our museum and ships.

Veterans Memorial Park offers a place for everyone to come, relax, and take a few moments to think about the people who have entered into the Armed Forces. With the backdrop of the Naval and Military Park, the monuments say everything—servicemen and women each know that they are risking their very own lives in the process of their service to create a country where we live out our dreams in freedom and liberty. Any single monument is cause for respectful reflection, but the awe and aura of the string of them along the walkway make one stand and pause. We then move quietly to the next and give thanks to those who gave their all for us.

(Right:) The Battle Within PTSD Memorial's goal is to help educate the public to this ongoing tragedy, provide a lifeline to the suffering, and honor our heroes for their service, regardless of where they died.

(Opposite:) Hispanic and Latino Memorial honors all Hispanic American veterans past, present, and future from all five branches of the Armed Forces. The Battlefield Cross, rifle pointing downwards capped with a helmet and a pair of combat boots, symbolizes a fallen warrior and their last march of the battle.

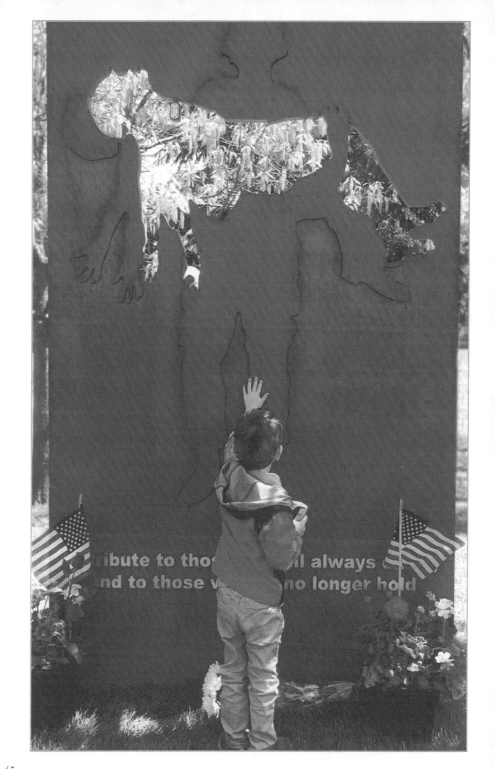

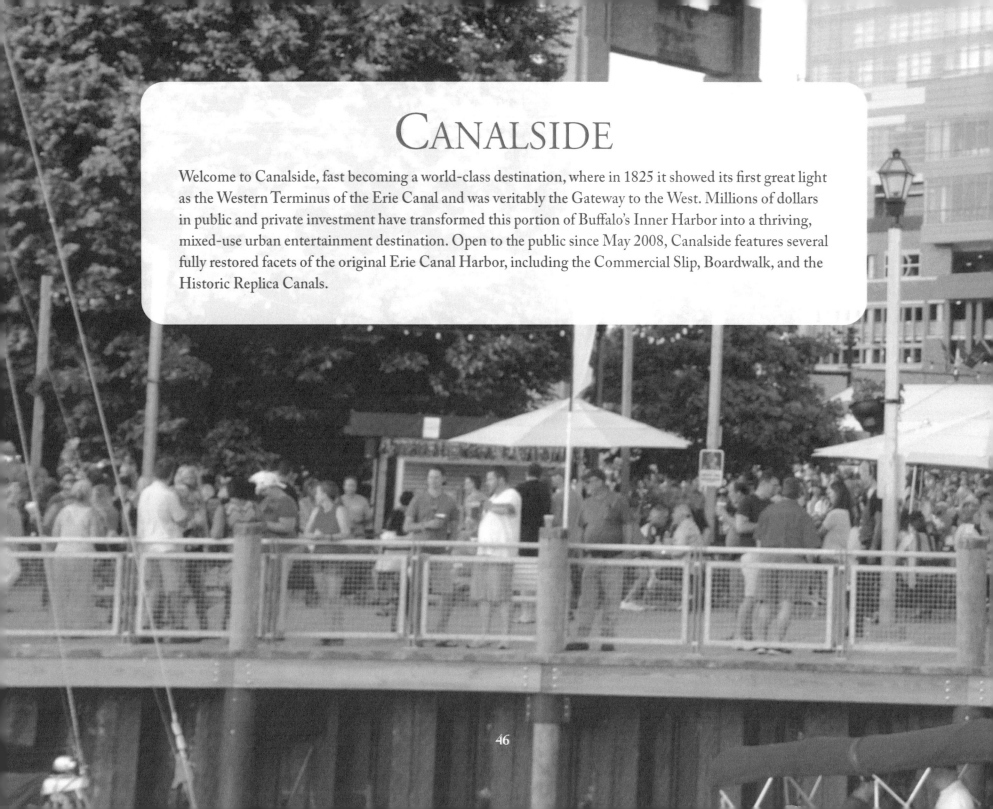

CANALSIDE

Welcome to Canalside, fast becoming a world-class destination, where in 1825 it showed its first great light as the Western Terminus of the Erie Canal and was veritably the Gateway to the West. Millions of dollars in public and private investment have transformed this portion of Buffalo's Inner Harbor into a thriving, mixed-use urban entertainment destination. Open to the public since May 2008, Canalside features several fully restored facets of the original Erie Canal Harbor, including the Commercial Slip, Boardwalk, and the Historic Replica Canals.

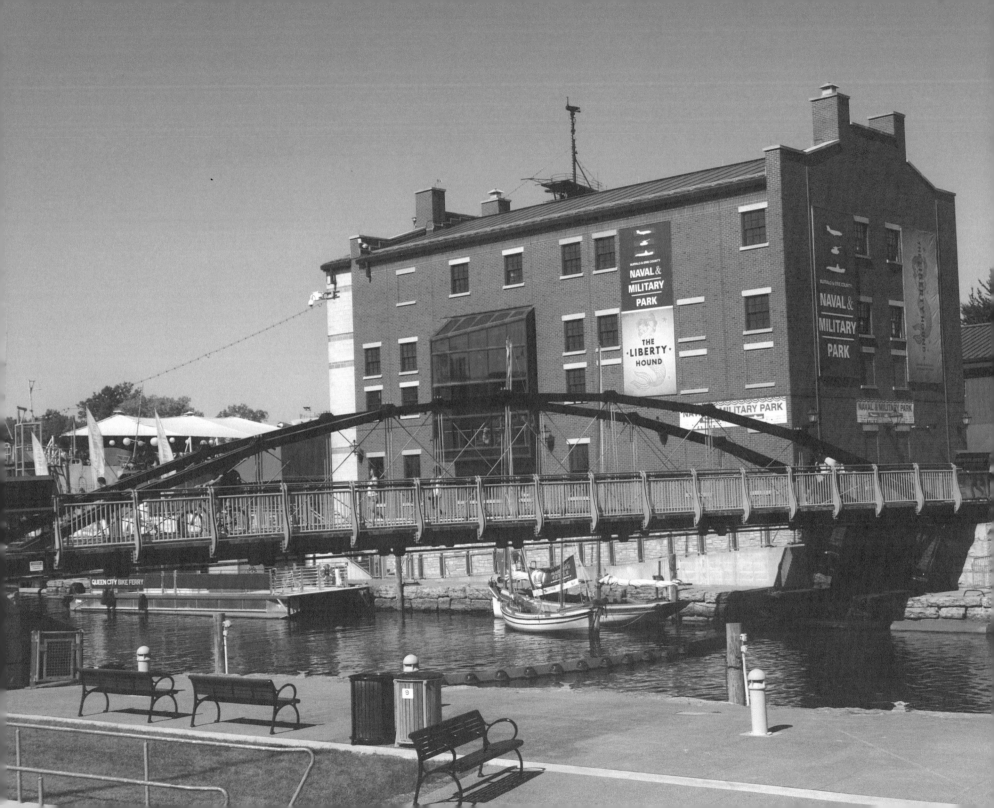

A Remarkable Transformation

Situated along 21 historic acres on Buffalo's inner harbor, Canalside is a growing regional destination and entertainment district. Viewing it today, it's hard to imagine this area was formerly known as "the Infected District", a hotbed for drunkenness and debauchery, especially among visiting sailors. At one count, there were 75 "houses of ill-fame" and over a hundred saloons, all within an eighth of a mile radius.

With roots dating back to 1825, Canalside takes its name from its storied past when the Erie Canal Harbor was the Erie Canal's western terminus and was veritably the gateway to the West. By the late 1920s, the Canal had been filled in by New York State, who saw the stagnant and polluted canal waters as a public health risk.

Today, Canalside is the gateway to Buffalo's future, blending its historic underpinnings with a massive upswing in private and public development. It's been spectacularly transformed into the go-to place for residents and tourists alike with more than 1,000 yearly events and nearly 1.5 million annual visitors–and growing.

As poignant reminders of its glorious past, there are many original elements at Canalside, including the refurbished "Commercial Slip", "Central Wharf", "Whipple Truss" foot bridge, cobblestone streets, and the excavated foundations of several canal-era buildings. Re-watered canals serve as a family playground with paddleboats in summer and ice skating in winter.

(Top right:) Buffalo's Canal Street neighborhood in 1872 was a dense, canal oriented neighborhood - Wikipedia
(Bottom Right:) Central Wharf, Circa 1870 - Courtesy Harvey Holzworth

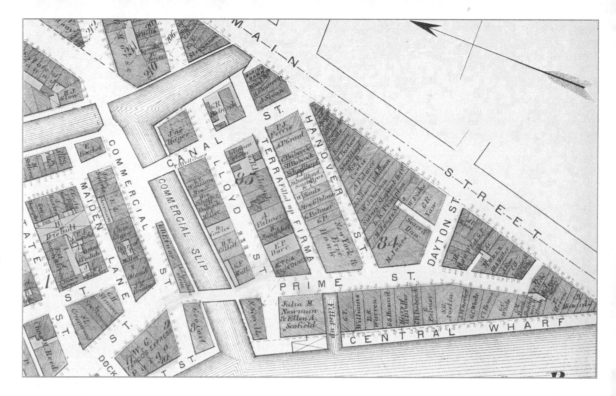

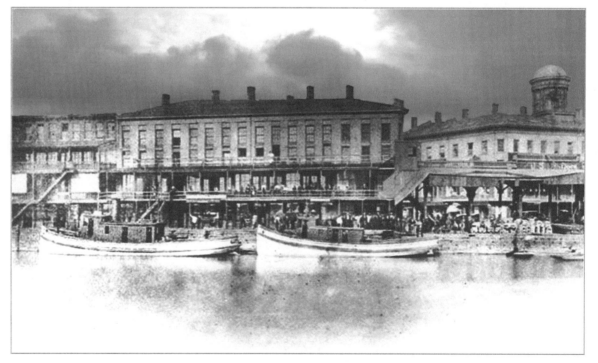

A Thriving Vortex of Activity

Canalside is more than the epicenter of Buffalo's water-front revival—it's ground zero for excitement. With a long roster of hundreds of events and activities, there is something to do every day, especially in the summer months.

Come and rent a kayak, paddleboard, or water bike, or hop on one of the numerous water tours. Grab a quick meal, a beer, or an ice cream cone. You can see a magic show, or free movies under the stars, or have your caricature drawn. Bring your mat for a yoga class and your sneakers for a lively fitness dance party, or simply become one with an Adirondack chair and take in our breathtaking sunsets. There's so much to do and so much to love.

(Right:) The Great Lawn at Canalside is Buffalo's premier outdoor concert venue where you can enjoy everything from rock to the Buffalo Philharmonic.

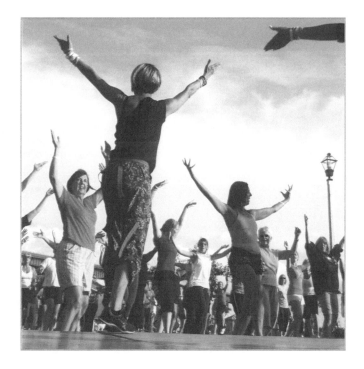

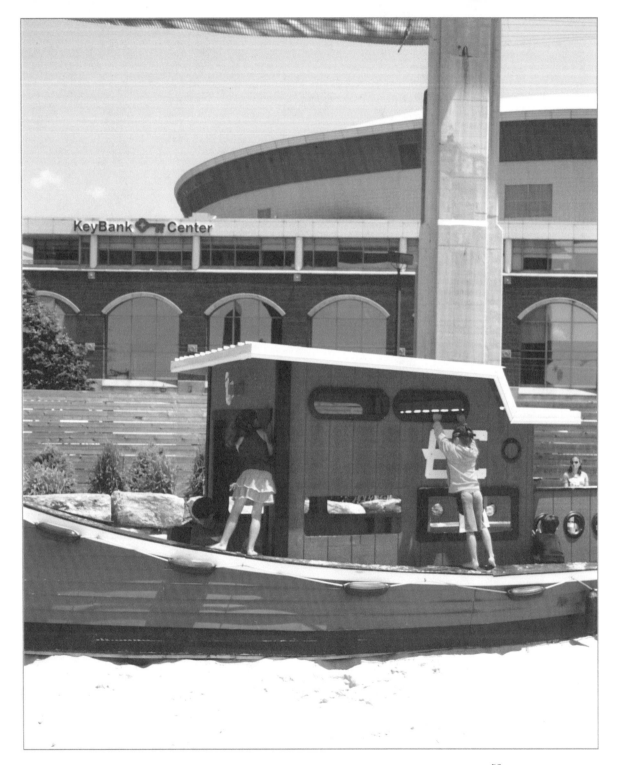

Canalside is a Kid's Paradise

Canalside is a magical place for young and formerly young kids filled with dozens of ways to capture their imaginations. It's buzzing with tons of children's programming, history tours, and outdoor activities.

(Opposite:) You can paddle your way through Buffalo's history, where shallow canals have been restored to how they were in 1825. Adult pedal boats and children's paddle boats, manufactured right here in Western New York, are available for hourly rental.

(Left:) If you follow the Boardwalk to its southern end, you'll find a large, partially enclosed play area where children play in the sand and let their fantasies run wild as captain the children's tugboat.

(Below:) A seemingly harmless, oversized Adirondack chair is actually a sinister trap waiting for unsuspecting old men.

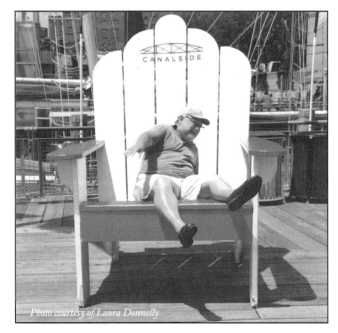

Photo courtesy of Laura Donnelly

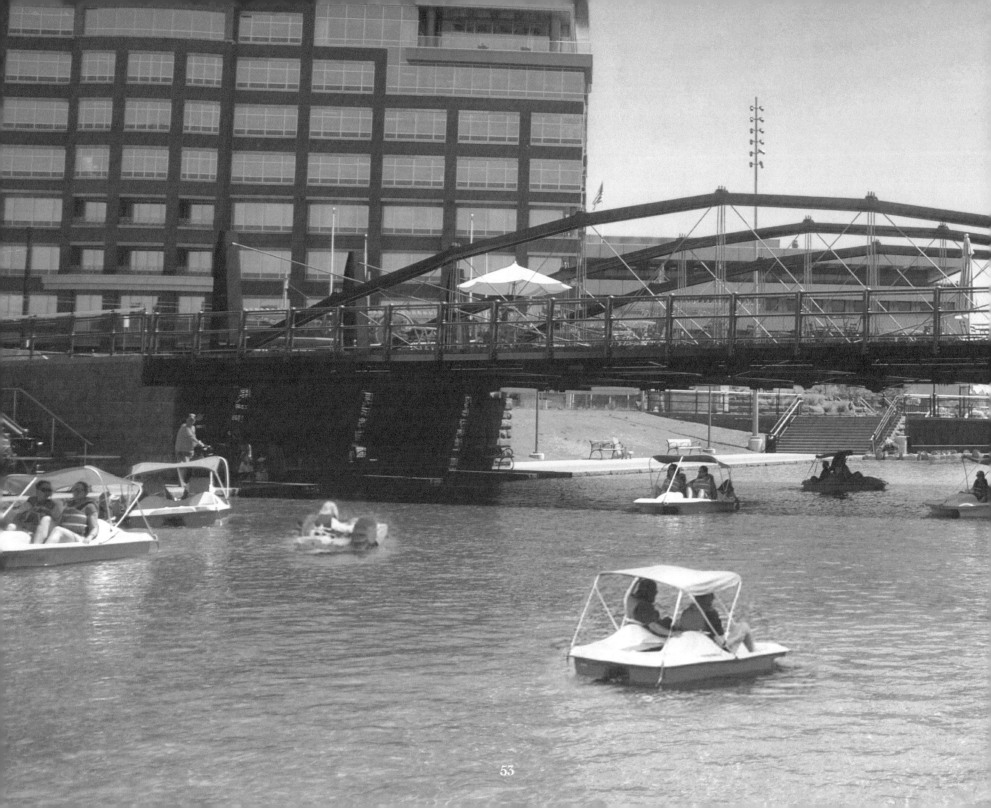

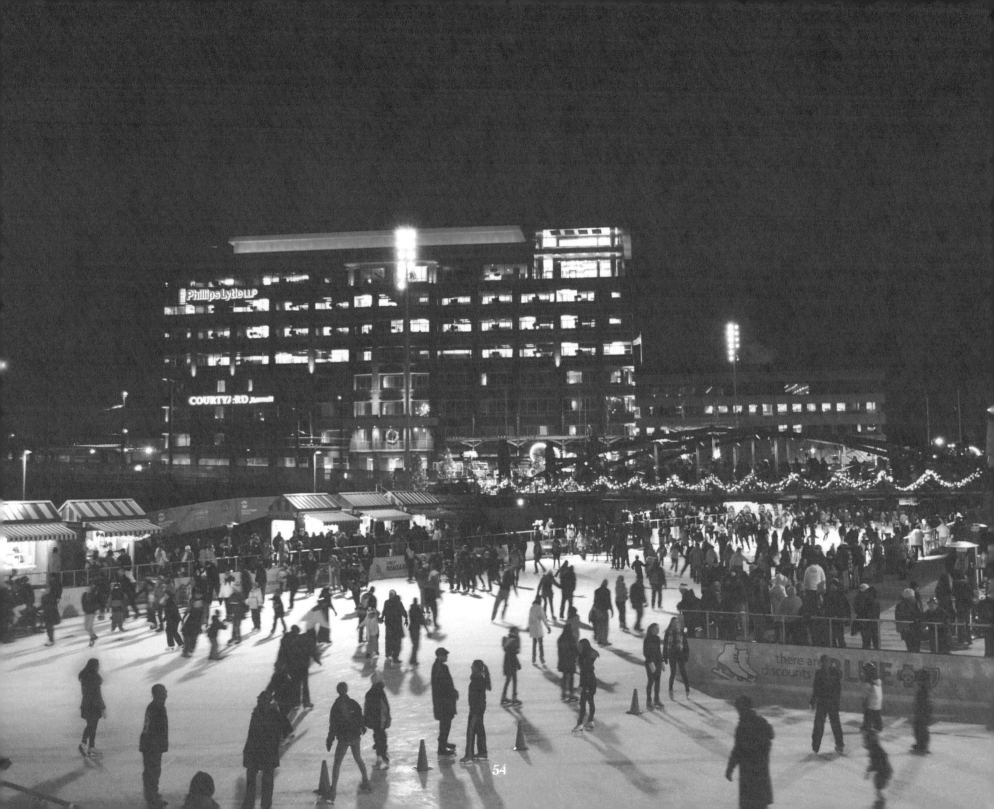

54

Winter Wonderland

When the temperatures dip below freezing, Canalside, Buffalo's beloved summertime waterfront destination, magically transforms. At the Historic Replica Canals, where paddleboats once cruised, now becomes a winter wonderland on New York State's largest outdoor ice skating rink. During Buffalo's fourth season, this becomes the domain of ice skating, ice biking (invented here in Buffalo), curling, and ice bumper cars on its 33,000 square feet of ice.

Ice Bumper Cars *(Right:)*
The newest way to enjoy the ice: slip, slide and smash your own ice bumper car with your friends and family.

Igloos at The Ice *(Below:)*
Now you can take a break from winter's favorite temperature. These igloos can accommodate up to 8 people in a cozy, intimate space to warm up and relax.

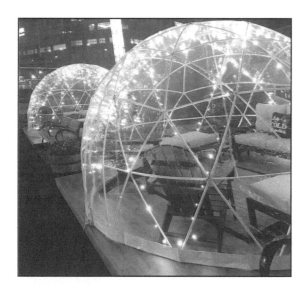

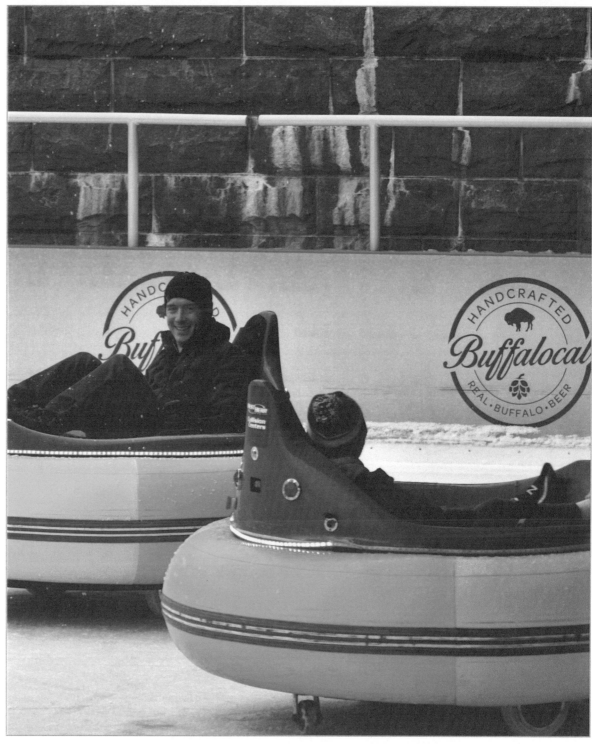

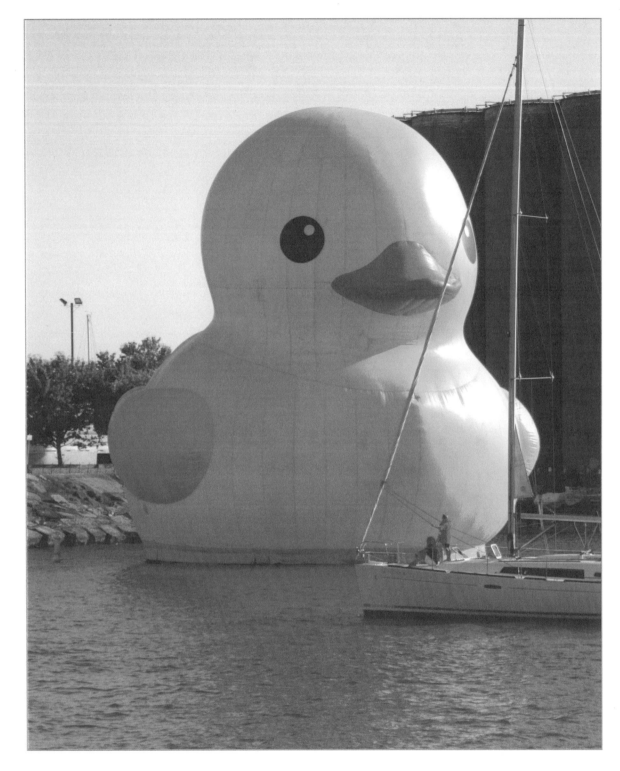

It's where happenings, happen

Canalside has become a powerful vortex of regional festivals, drawing thousands to the waterfront. The boardwalk and lawns play host to hundreds of events throughout the year, many of which are free or low cost to the public.

Basil Port of Call: Buffalo *(Opposite:)*
In 2019, the Buffalo Lighthouse Association drew 125,000 visitors to the waterfront for the Basil Port of Call: Buffalo Fsestival at Canalside, Lighthouse Point, and two other nearby waterfront locations.

World's Largest Rubber Duck *(Left:)*
Floating at the tip of Kelly Island, a six-stories high rubber duck visited Canalside for a weekend as part of the Buffalo Maritime Festival.

(Below:) Canalside plays host to many major festivals such as the Maritime Festival, Pride Festival, Canalside Boardwalk Carnival, Fourth of July fireworks, Gospel Festival, Autorama, and Fall Festival, to name a few.

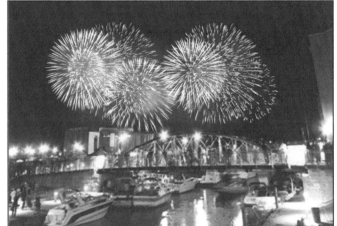

The Longshed Building *(Bottom Left:)*

New at the northern end of the Central Wharf is the Longshed building; a two-story, gabled-roof wood structure reflects the site's history. It incorporates elements from the Joy and Webster Storehouse located on the site in the early 1800s. The approximately 4,400-square-foot Longshed includes a main floor that stretches the building's length, a smaller mezzanine level, public bathrooms, roll-up entry doors, and an exterior porch that overlooks the Canalside lawn.

Initially, the building will be used by staff and volunteers from the Buffalo Maritime Center to construct a replica of the 1825 Seneca Chief packet boat, which transported Governor DeWitt Clinton from Buffalo to New York City to mark the official opening of the Erie Canal. The packet boat project is expected to take about three years to complete. During that time, the public will be able to watch the boat being built and even volunteer to join the construction crew.

Buffalo Heritage Carousel *(Bottom Right and opposite page:)*

The historic century-old De Angelis Menagerie Carousel's 34 hand-carved animals was built in 1924 at the Herschell-Spillman factory in North Tonawanda but then went into storage for 80 years. Its sights and sounds can now be enjoyed by children for generations to come.

The solar-powered carousel will be located near Clinton's Dish inside a glass enclosed roundhouse. It's a grand celebration of both Buffalo's industrial history and our ongoing work to revive and transform Buffalo's Waterfront.

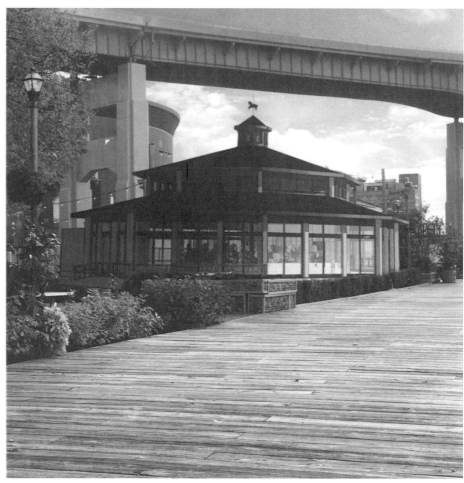

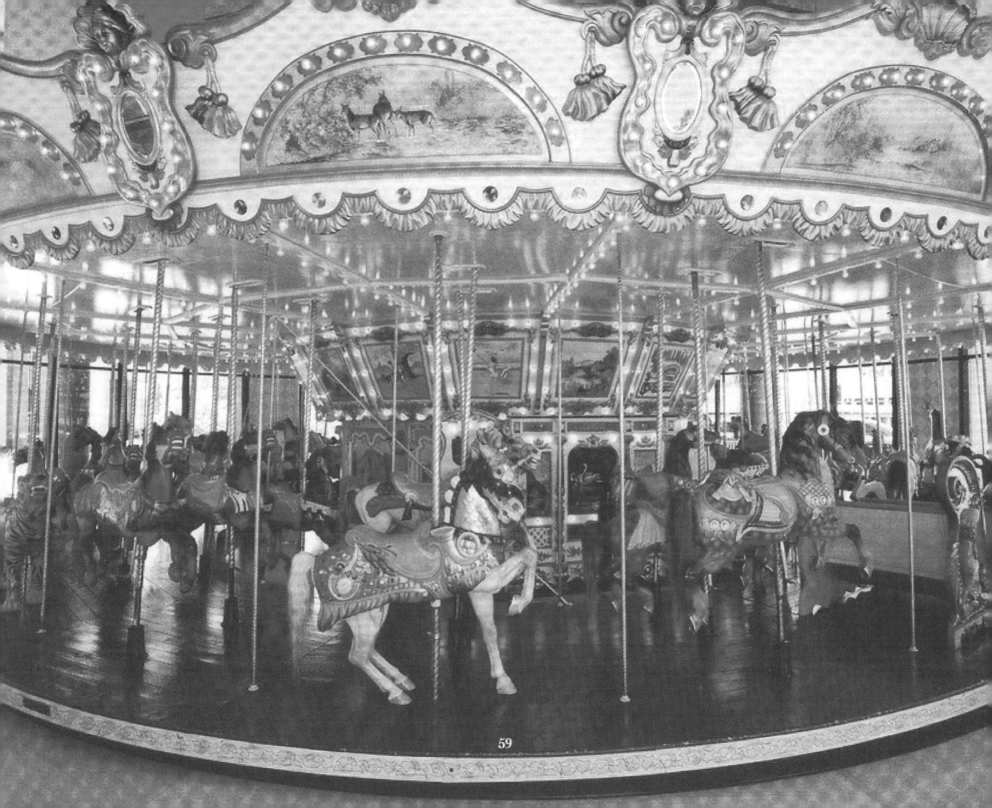

59

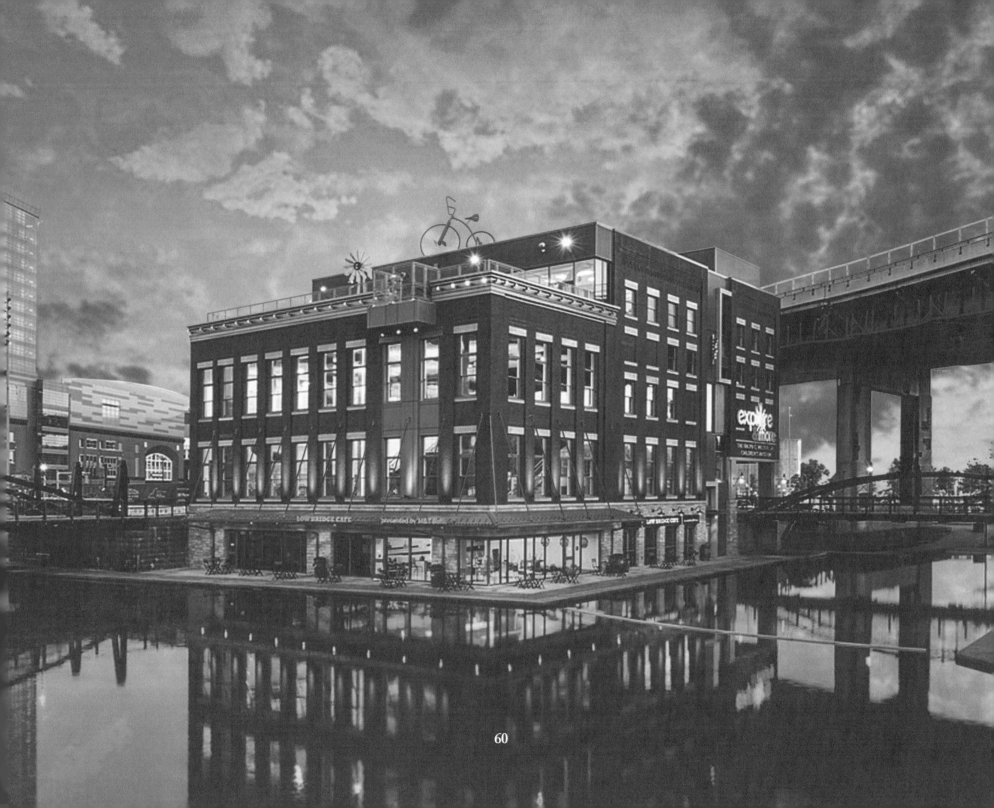

Explore & More - The Ralph C. Wilson, Jr. Children's Museum

Promoted as "Where fun and learning play together," Explore & More-The Ralph C. Wilson, Jr. Children's Museum is a 43,000 sq. ft, world-class children's museum that celebrates the power of child-led play.

Tucked between Canalside's replica canals and bridges, the museum has become a year-round must-see destination for anyone with children. There are four floors of fun with seven different play zones to explore, featuring thoughtfully crafted exhibits. They are designed to help children develop a deeper sense of our world, our community, and their place in it.

Learning seamlessly happens here in a fun and engaging way for children and adults alike. The museum amplifies our sense of place by showcasing Buffalo's history, waterways, sports teams, diversity, and invention contributions. Children can also learn how to grow plants, cook a meal, and be creative in the art studio.

Explore & More is a place where learning feels like playing, where "Do not touch" becomes "Try it out". And where there's always a reason to come back for more.

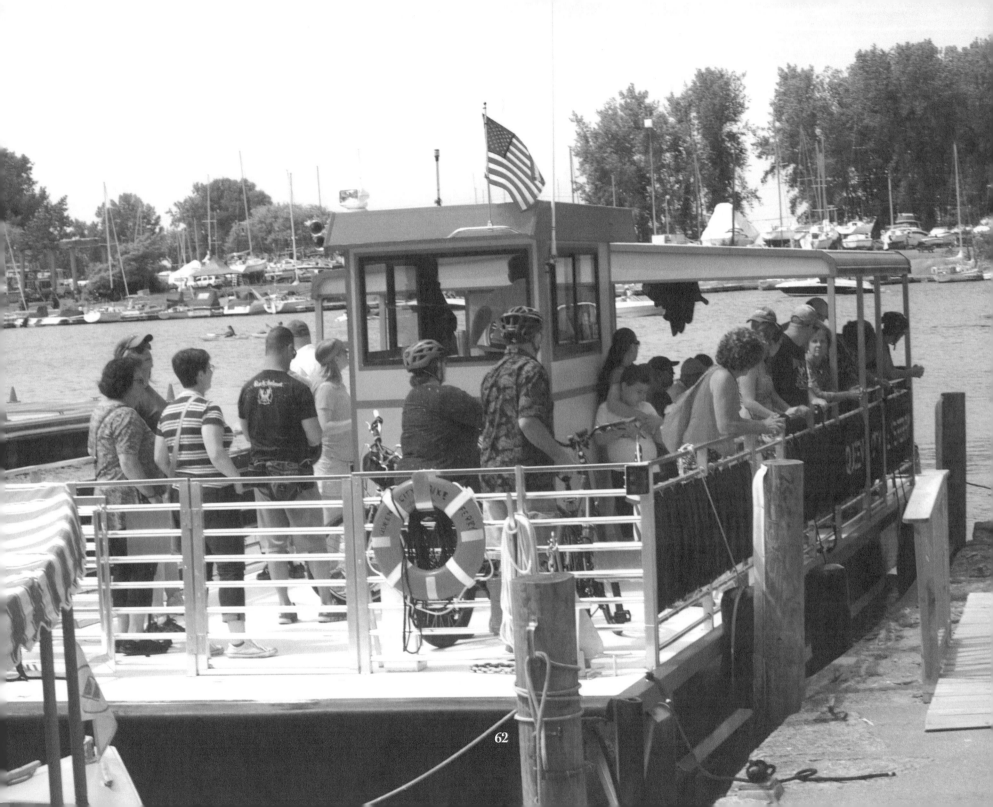

62

Queen City Bike Ferry & Landing

The Queen City Bike Ferry connects pedestrians and bicyclists from the Commercial Slip at Canalside to the Outer Harbor and back daily from Memorial Day through Labor Day for $1 per person each way. This inexpensive 600-foot passage across the Buffalo River is a convenient link for non-motorized vehicles providing easy walking and bike access to points on the Outer Harbor.

In 2015, its first year of operation, the Ferry exceeded expectations as it welcomed over 50,000 riders. During the offseason, ECHDC invested $825,000 into a revamped Ferry landing at the Outer Harbor, which was designed to improve the pedestrian-bicycle trail system along the waterfront, providing a direct link to the water's edge, and a rest area for riders.

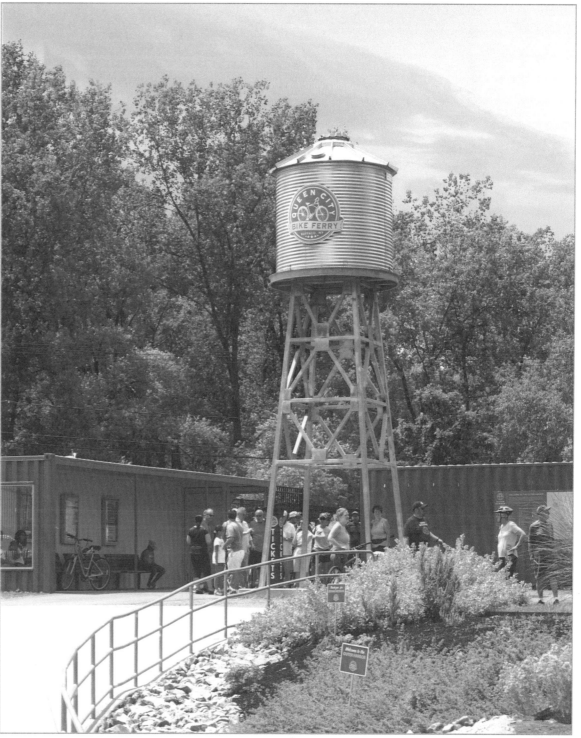

63

OUTER HARBOR

From the 1833 Lighthouse and Coast Guard Station Buffalo to Buffalo Harbor State Park at the most southern point, the "Outer Harbor" offers a variety for a visitor to see and do. Sandwiched between these two points, our waterfront is being transformed with multiple locations for people to access and enjoy the water's edge.

Walk. Run. Bike. Boat. Picnic. Play. At the Outer Harbor, your options for adventure are wide open, or you can just relax and take in spectacular waterfront sunsets.

Explore the wild side of the city at the Times Beach Nature Preserve on its well-marked paths and observation blinds for viewing a wildlife habitat that draws transitory birds on the major flyways.

From the magical views and sunset strolls to the beehive of activity, the pearl of the Outer Harbor can be found at Wilkeson Pointe. Ride your bike, unpack your picnic basket, unfold your chairs, unload your kayak, serve up a volley, and bask in the serene glow that this public space has to offer. Bike and water sport rentals are available here, the kayak launch is open daily to the public, and the "The Pointe" beer garden is open daily.

Starting at Wilkeson Pointe, the 3-mile Independent Health Wellness

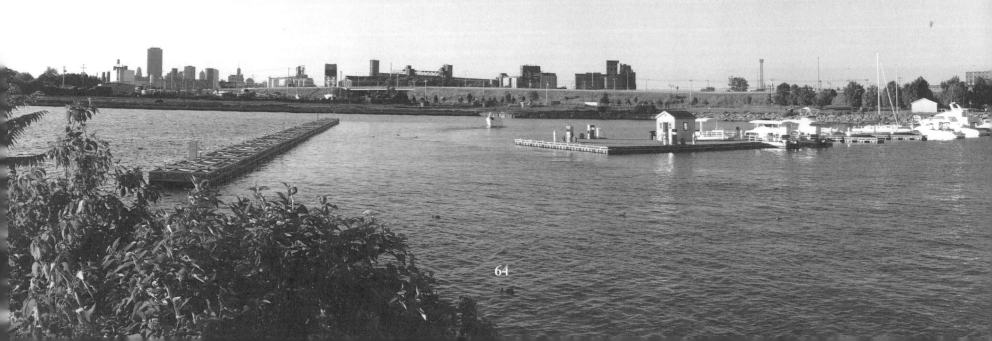

Trail is perfect for running, walking, jogging, biking, roller skating, and more that brings you along some of the best views of the waterfront. It includes the Outer Harbor Event Space, Bell Slip, and continues through the new bike park. Lakeside Bike Park offers three mountain bike tracks for riders of all skill levels and ages.

Buffalo Harbor State Park *(Below:)* is home to a 1,100 slip marina, a restaurant, boat launches, personal watercraft launches, fish cleaning station, restrooms, and a beach for strolling and sunbathing, and a nautical-themed playground great for kids of all ages.

For decades Buffalo's Outer Harbor and waterfront sat desolate and underutilized until 2005, when ECHDC spearheaded Buffalo's waterfront revitalization, reclaiming the area as one of America's brightest historical treasures. ECHDC's mission is to revitalize Buffalo's Inner and Outer Harbor areas and restore economic growth to Western New York, based on the region's legacy of pride, urban significance, and natural beauty.

In 2014, ECHDC acquired approximately 350 acres of property owned by the Niagara Frontier Transportation Authority located on Buffalo's Outer Harbor. At the governor's direction, the boat harbor and beach have become Buffalo Harbor State Park, and the remaining vacant land is being activated.

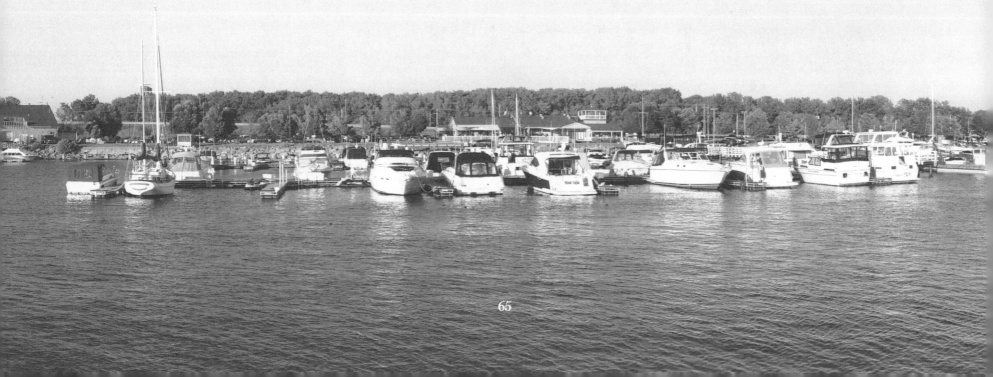

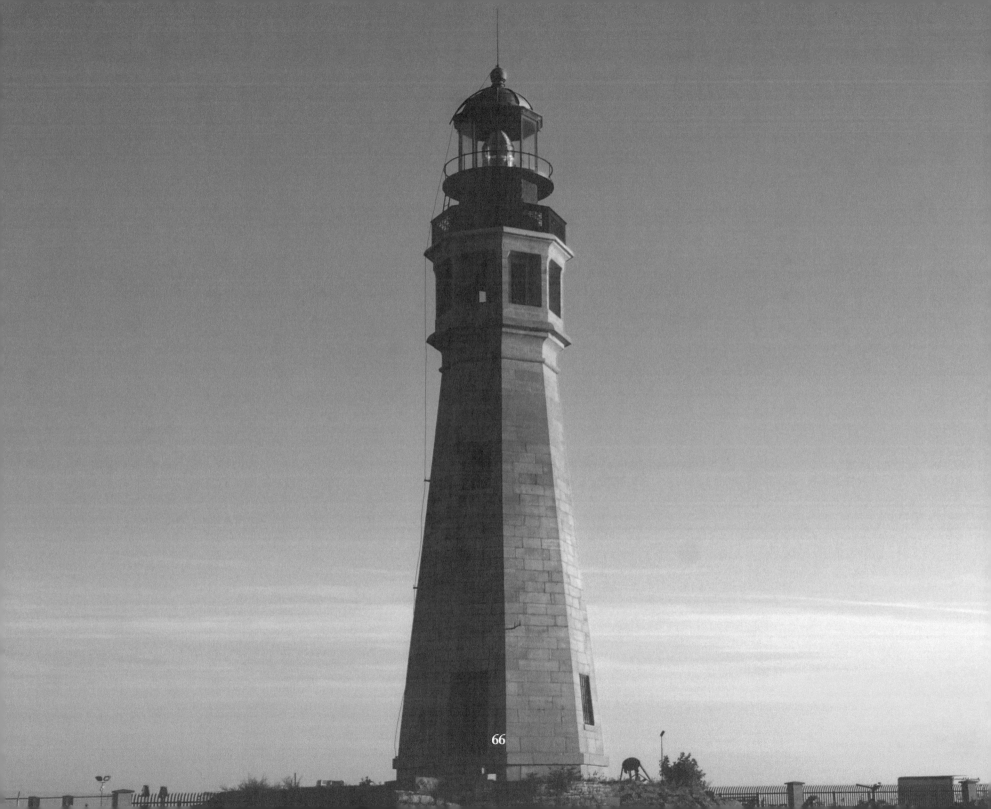

66

Buffalo Lighthouses

Imagine his relief when the captain aboard his ship on Lake Erie came through its often wild tumult of winds, rain, sleet, fog, and waves to finally see the beacon of a Buffalo lighthouse welcoming them to a safe port.

Lighthouses are the quintessential symbols of guardianship. Their legacy on Buffalo's waterfront is firmly rooted in guiding mariners safety for two centuries. Today, the lighthouses' images share space on store racks selling everything from mugs to towels, alongside images of cats, teddy bears, and other adoptions of sentiment. But there was a time of rigor, valor, and significance to the day-to-day rites and duties of these beacons.

Lake Erie has been called many things, including the Cemetery of the Great Lakes, scoring numerous shipwrecks in a 300-plus year history. A remarkably shallow lake, mariners often liken navigating her to that of running up a set of stairs carrying a bowl of soup. Our Buffalo forefathers countered this safety need by constructing several lighthouses in various

size and style structures designed to emit light from a system of lamps and lenses providing navigational aid to Erie's maritime pilots.

Nothing blends design art and mathematical science better than the actual lights used in Buffalo's lighthouses, called a Fresnel lens. Lake mariners today rely on automated systems of aero beacons and light-emitting diode panels. Still, the days of the Fresnel lens are not all lost, thanks to the Buffalo Lighthouse Association's efforts to restore and replace these costly beacons. The Fresnel's essence was its ability to focus 85% of a lamp's light versus the 20% focused with the parabolic reflectors of the time. The design enabled lenses of a large size and short focal length without the weight and volume of material in conventional lens designs.

Now start at Buffalo Main Light, or Buffalo Light, the best place to begin your lighthouse tour. Her very image makes up the heart and spirit of our City Seal. This prominent 66 foot stone tower stands sentinel at the entrance to the Erie Canal and was built in 1833 when the original light was deemed inadequate for

the increased ship traffic entering and exiting the Buffalo River. Buffalo Light is located on the beautiful grounds of Lighthouse Park, which also boasts a restored 1903 breakwater light, called a bottle light for obvious reasons. And visible from the marina are the ruins of the Horseshoe Reef Light and the Buffalo Intake Crib Light.

Moving three miles south to the end of the Outer Harbor at Stony Point, you'll find the Buffalo Harbor South Entrance Light, also known as the South Buffalo Lighthouse. It was established in 1903 and deactivated in 1993 when it was replaced by a nearby modern post light. The lighthouse property consists of a three-story cast iron 43.5-foot decommissioned light tower topped with a lantern.

A lighthouse is critical when you seek to see a hazard or a port, but sometimes the fog or storm is so thick nothing can be seen, and that's when a "sound house better serves a 'lighthouse'." For the testing and development of such sound and horn signal testing, the Great Lakes called upon Buffalo. Adjacent to the South Buffalo Lighthouse tower is a one-story concrete fog signal building, also known as the Horn Testing Center, whose scientific horn research was on par with the endeavors of the time led by Marconi's radio research. As a horn testing center, better and various methods were developed in far-reaching and shore combing sound signals to relieve mariners in times of low visibility or fog. It was listed on the National Register of Historic Places in 2007.

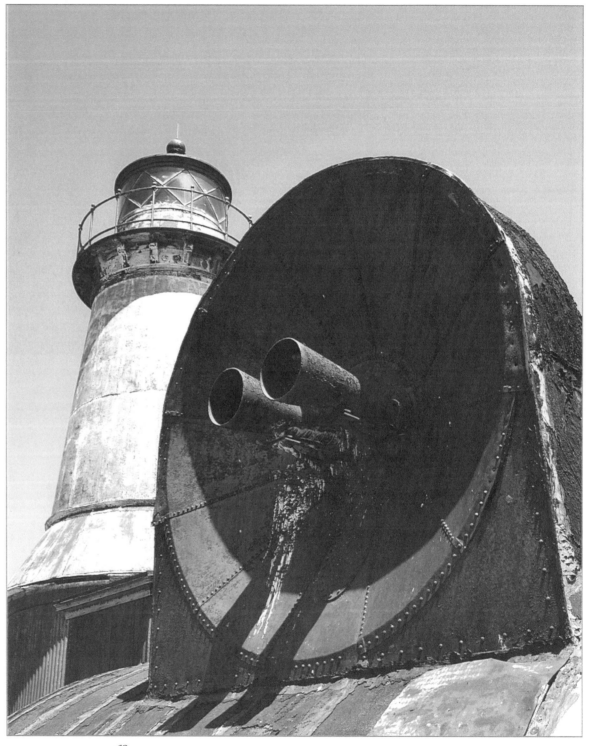

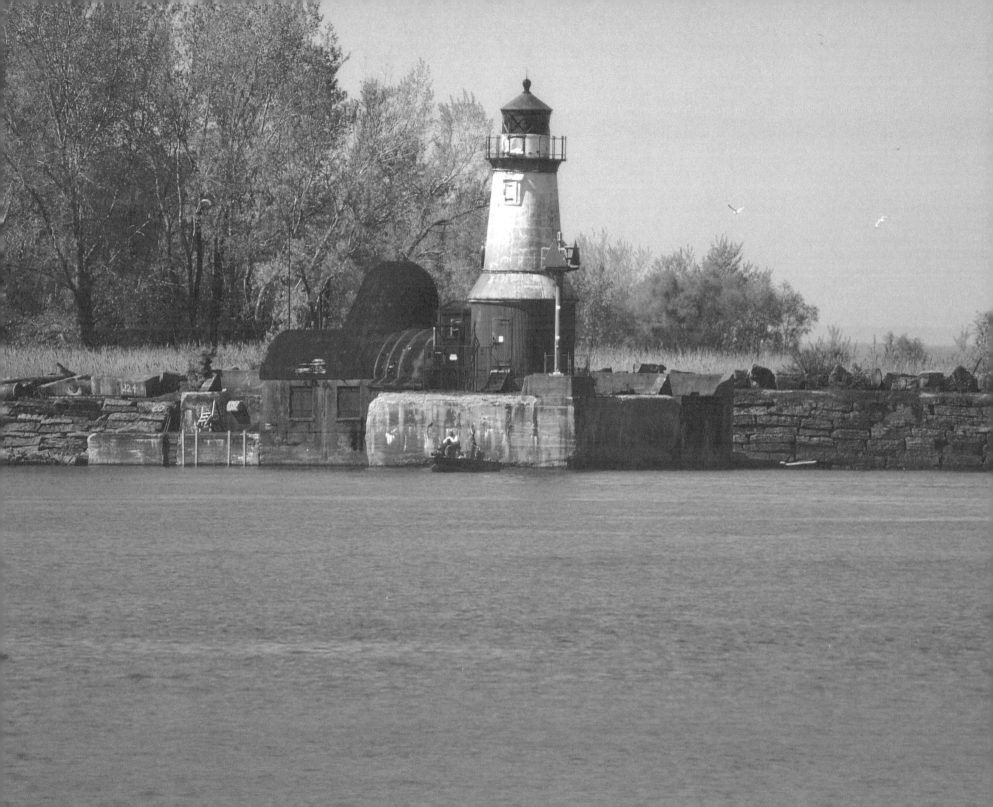

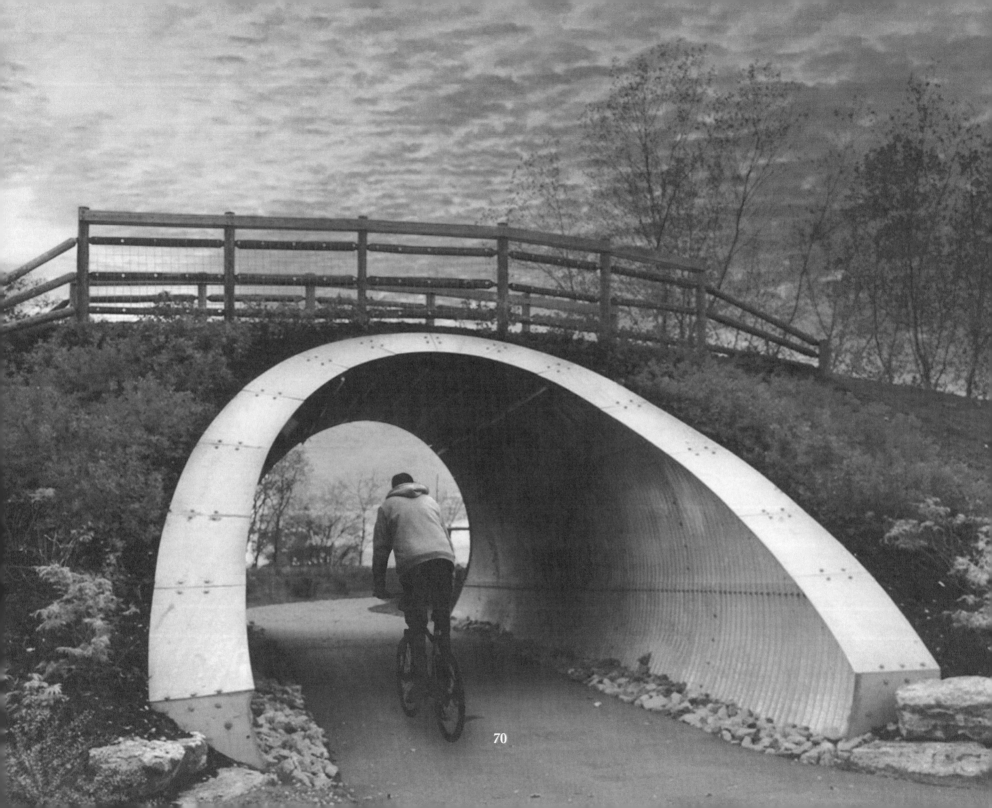

Pedal Power

The Outer Harbor Trail *(Left:)*
This trail parallels Fuhrmann Blvd, which runs over four miles along the Outer Harbor from Lighthouse Point Park at the Coast Guard Station to the Union Canal at Stony Point, Lackawanna. Along the way are six parks, preserves, or green spaces you can visit.

Paved bike pathways line the Outer Harbor Parkway with great sites to see along the way. Pedaling along, you'll enjoy a spectacular view of the Outer Harbor. The trail passes new landscaping readdressing the industrial image of old—replete with new trees, floral bush mid-islands, and period lampposts. The stylized cement arches over road viaducts serve as the portals to the Old First Ward neighborhoods and nature reserves on the other side of the Skyway, among them the Tifft Nature Preserve and the City Ship Canal.

Buffalo's Outer Harbor waterfront offers a mix of industrial and natural, old ship docks, lakeside warehouses, and grain elevators.

Wilkeson Pointe is an outer harbor park with bike rentals and a multitude of pedestrian paths. Ride to the top of the hill to view one of its most striking features; the Wind Sculptures that rise above the site, framed in beautiful views of the sunset over the water.

Lakeside Bike Park *(Opposite:)*
The bike park provides three introductory-to intermediate-level tracks for mountain bike riders. The activity zone includes a pump track, skills loop, and total track with a viewing area and concourse. Nearly one mile of dirt trails is installed throughout the site and presents varying degrees of skills and obstacles.

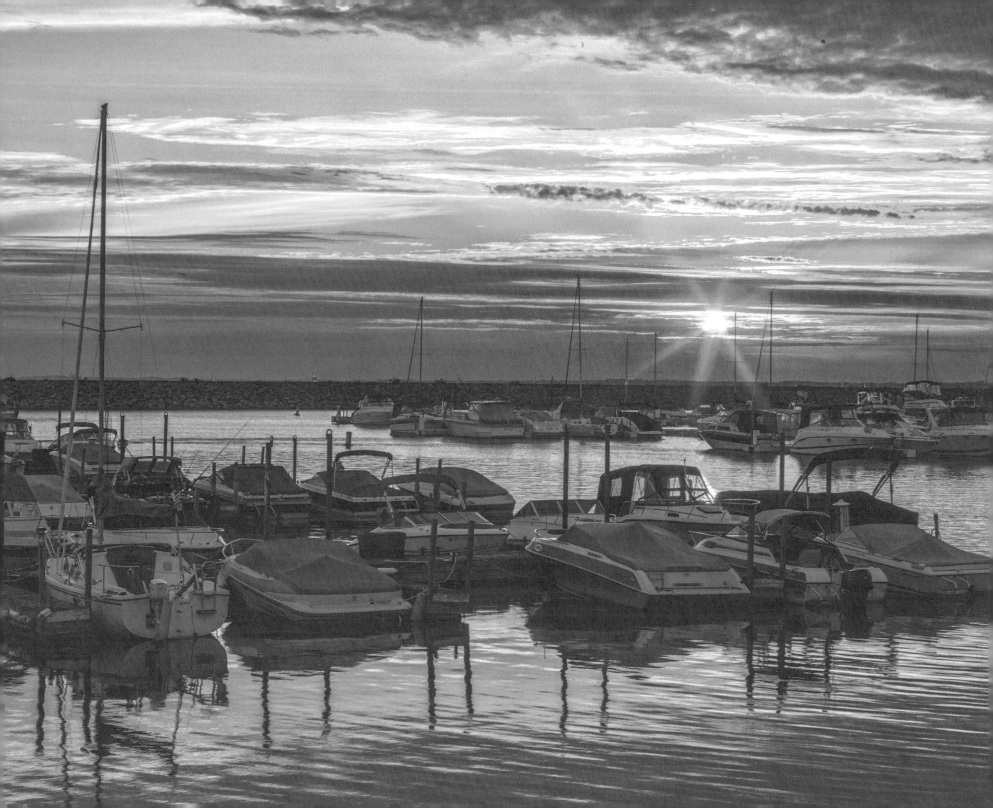

Buffalo Harbor State Park

The newest state park in the system, Buffalo Harbor State Park, is the first state park within the city of Buffalo. Boasting beautiful views of Lake Erie, the park is home to a 1,100 slip marina, Charlie's Boat Yard restaurant, boat launches, personal watercraft launches, fish cleaning station, restrooms, a beach for strolling and sunbathing, and a nautical-themed playground great for kids of all ages.

A bike and pedestrian trail now extend the entire length of breakwall ending at a circular Promenade, perfect for watching boats entering and leaving the marina.

Buffalo Harbor State Park is host to several special events and is a great place to enjoy a summer day in Western New York.

Within the grassy area between the marina and Gallagher Beach are modern picnic shelters and a spectacular destination playground nearly impossible to get children to leave.

(Left:) Buffalo Harbor State Park features a playground with nautical-themed activities such as spinning cattails, slides built to look like a stylized ship, and a rocky shore for climbing.

(Opposite:) The sun setting on the marina's vibrant community of both power and sailboats © *Photo by Eileen Elibol*

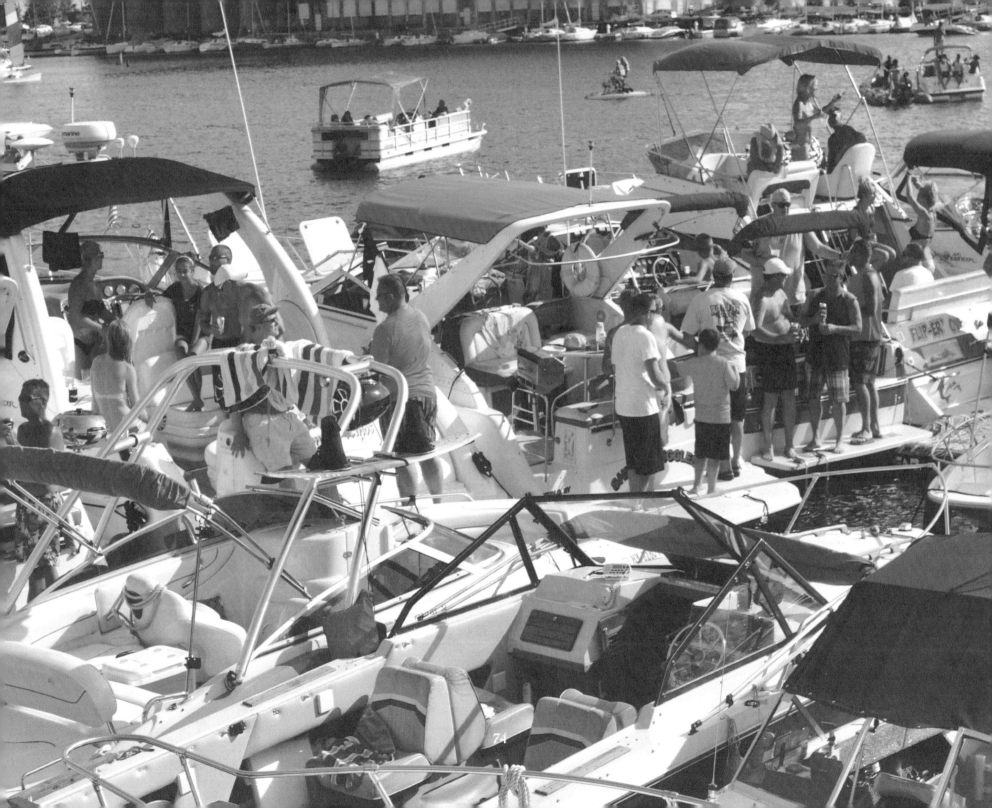

On The Water

There is no better view of our amazing waterfront than actually being on the water with the sun in your face and the wind in your hair. Whether it is touring our river and lakes on the Miss Buffalo, Grand Lady, Spirit of Buffalo, and Moondance Cat; sailing; or aboard one of the many available forms of personal watercraft, Western New York never looks better than when you are surrounded by water.

(Opposite:) Rafting boats from the dock at Canalside, often as many as a dozen deep, creates an instant floating party and a great jumping-off point for activities on the Commercial Wharf.

Jet Skis *(Bottom right:)* are those buzzing, quick wave jumping machines that crazy young people use to wrinkle the water and create noisy confusion on pleasant sailing days. These aqua scooters are personal recreational watercraft where the rider sits or stands, rather than inside.

SCUBA *(Bottom center:)* in Lake Erie holds the lure of thousands of undiscovered shipwrecks boasting more "wrecks per square mile" than any other freshwater location in the world.

Water Bikes of Buffalo *(Bottom left:)* are exercise with a view. You can rent single and tandem bikes by the hour from the dock at Canalside.

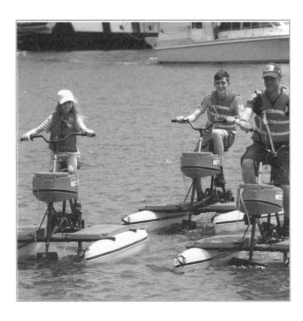
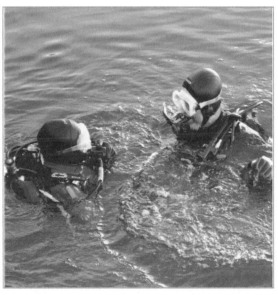
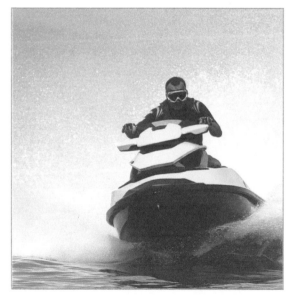

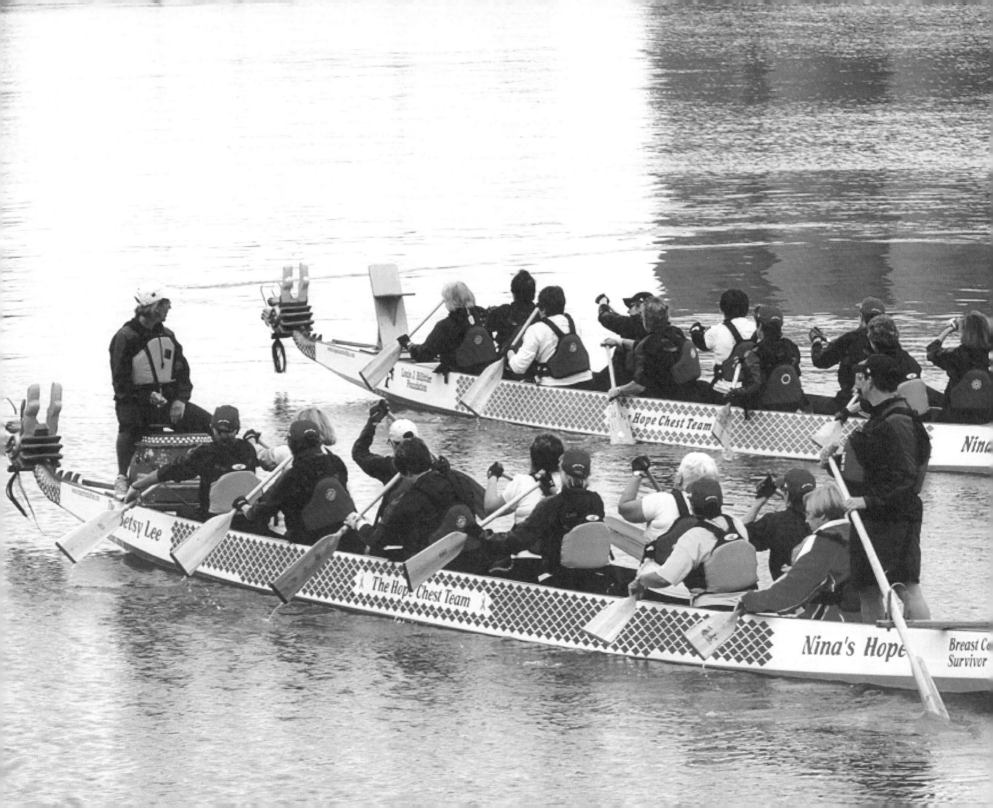

Hope Chest Dragon Boat Team *(Opposite:)* is group paddling with a purpose. They're a health and fitness program that promotes physical and emotional healing for breast cancer survivors of all ages and fitness levels.

Kayaking *(Right:)* is an exciting urban-nature experience as you paddle your way up-close and personal past the towering grain elevators, naval ships, and a variety of wildlife, accompanied by the sweet smell of Cheerios.

Windsurfing *(Below:)* is a personal watercraft using a sail instead of a motor. On a windy day, when the waves are high, windsurfers can be seen braving the forces at Gallagher Beach up and away, and sometimes down. They bounce back up and away at speeds to make a parent's heart faint.

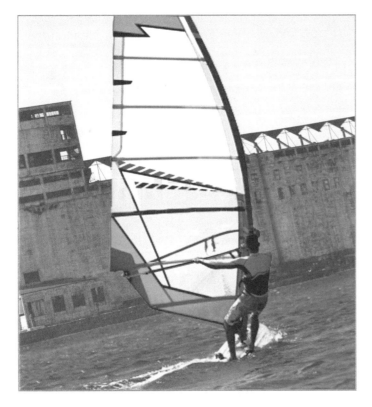

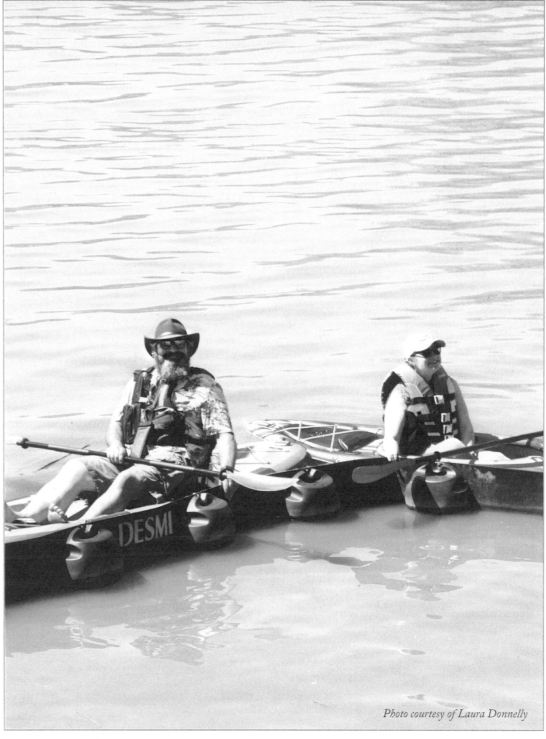

Photo courtesy of Laura Donnelly

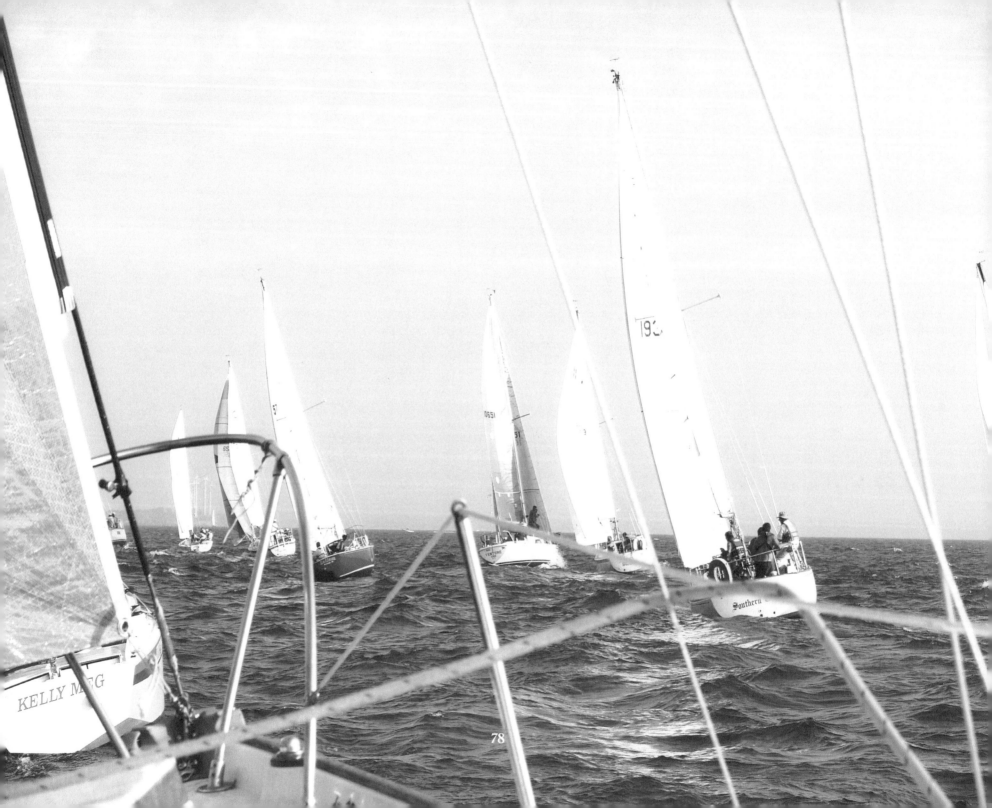

Sailing

For peace, quiet, and an unrivaled connection to Lake Erie, there's nothing quite like sailing. While sailing, you're part of a tradition that's more than 3,000 years old. Sailing and sailboats are among the most important inventions in human history. Using nothing but the power of the wind, you'll leave the noise, confusion, and stress of the world behind for a few hours and experience the incomparable sense of freedom and solitude.

The hundreds of beautiful sailboats lining the Buffalo River across from Canalside, or at any one of our marinas, is a testament to Western New York's passion for this sport.

Buffalo Harbor Sailing Club's (BHSC) fleet of sailboats races every successive Tuesday and Wednesday *(Opposite:)* throughout summer on Lake Erie, making it arguably one of the largest sailing racing fleet clubs in North America. Reasons for its size and unity are myriad: some say it's the short season that binds them; others point to cities where racing fleets are split among half a dozen yachting clubs or more.

Buffalo Yacht Club *(Left:)* was founded in 1860, making it the third-oldest yacht club in America. The BYC is also the only twelve-month, private yacht club that enjoys two locations in two countries.

Rowing

There are two boathouses located in Buffalo, the West Side Rowing Club (WSRC) and the Buffalo Scholastic Rowing Association (BSRA).

BSRA was founded in 2010, and its crews row right by Canalside, while WSRC was founded in 1912, and its crews row in the Black Rock Canal.

The West Side Rowing Club is the nation's largest rowing club. For many years, the WSRC has provided the Buffalo-Niagara region with access to the sport of rowing. Their high school, college, and community programs produce championship crews and have won national recognition for our region. They have produced numerous Olympic rowers

Through the sport of rowing, the Buffalo Scholastic Rowing Association enriches the Western New York and Old First Ward communities. They provide access to safe, fun, and affordable recreation educational opportunities on the Buffalo River.

Rowing in the First Ward has a rich and storied past. The Mutual Rowing Club at the riverside intersection of Hamburg and South streets was the social heart of the First Ward for five decades, beginning in 1881 and ending in the early 1930s. The club sponsored legendary regattas, which reportedly attracted up to 10,000 spectators lining the Buffalo River's bend. Residents dressed up in their Sunday best to picnic and root for their local heroes.

(Bottom left:) MRC members circa 1895 carrying a scull from the clubhouse to their dock. *(Bottom right:)* The boathouse at Mutual Riverfront Park is loosely modeled on the historic 1892 MRC brick clubhouse.

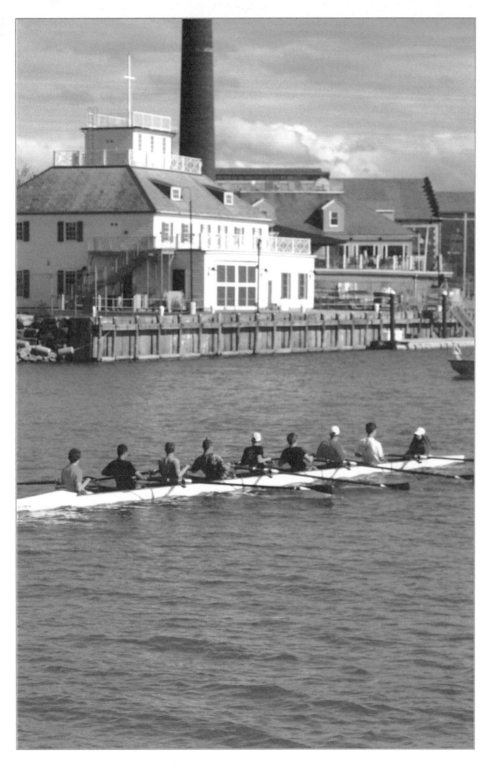

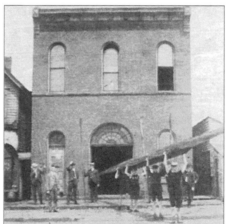

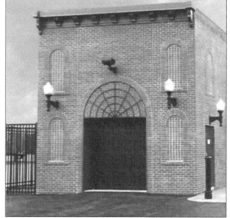

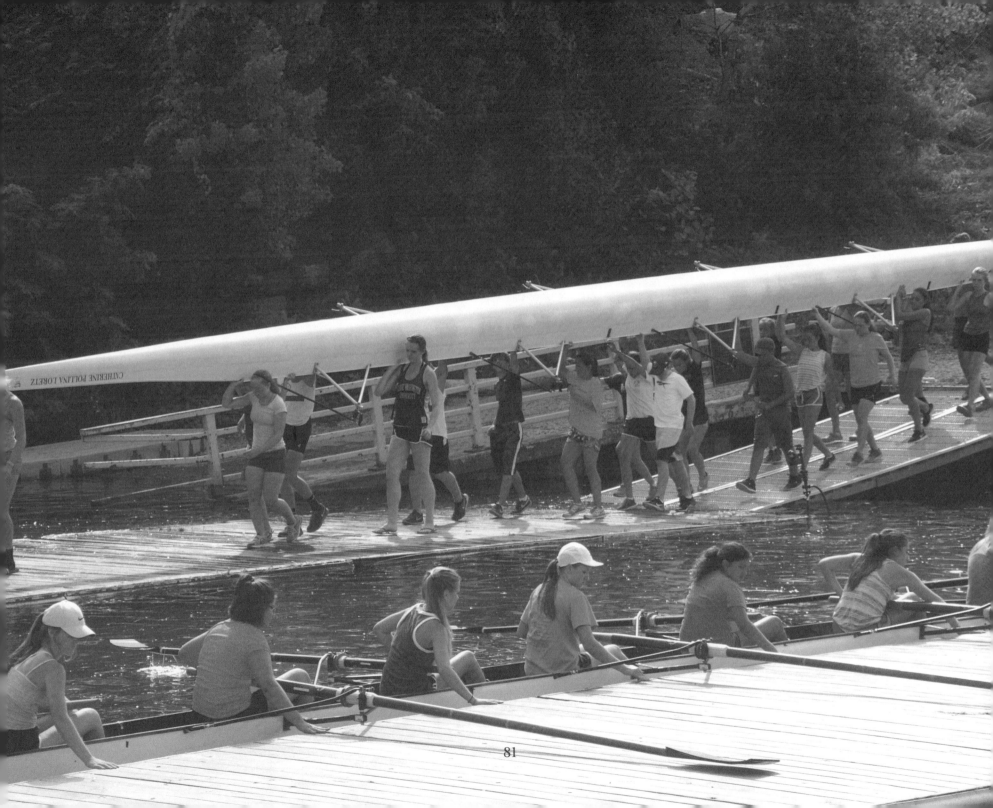

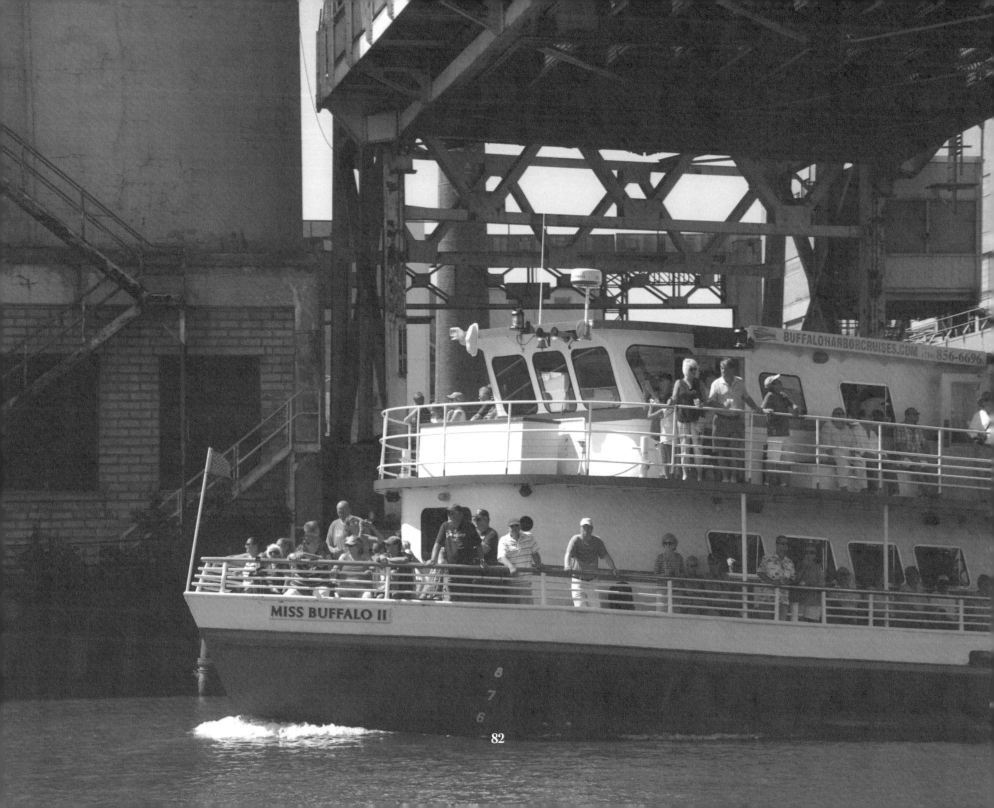

MISS BUFFALO II

BUFFALOHARBORCRUISES.COM (716) 856-6696

Tours

One of the best ways to explore Buffalo's Inner and Outer Harbor, Niagara and Buffalo Rivers, and other waterway attractions is by boat. There is no shortage of vessels traversing the water and offering public access, from sightseeing tours to dinner cruises and even a private ship excursion.

From a variety of narrated boat tours of the waterfront, you'll learn about the city's maritime and industrial history and informative notes on the resurgence of the waterfront, pointing to new developments that just happened, are happening, or soon will happen.

Miss Buffalo II *(Opposite:)*
Welcome aboard Miss Buffalo II to enjoy sightseeing, weekly scheduled parties, scenic views, romance, great entertainment, and fun for the whole family! City skylines and picturesque sunsets await you aboard the Miss Buffalo II, the Niagara Frontier's best excuse for a party on the waterfront. Sightseeing, private charters, and parties can be booked any week all summer long. Enjoy sightseeing tours of Historic Buffalo and its architecture or a guided tour through the Historic Buffalo River and the grain elevators. There are also narrated tours of Lake Erie, the Niagara River, and navigating the Black Rock Lock and Canal.

Queen City Ferry
Going somewhere, or just getting away, the Queen City Ferry offers river tours and water ferry service between Buffalo's Inner and Outer Harbor. You can board the Queen City Ferry at the Central Wharf, which then travels to the Outer Harbor, Erie Basin Marina, and along the Buffalo River to Riverfest Park in Buffalo's old First Ward district. The round trip takes approximately one hour.

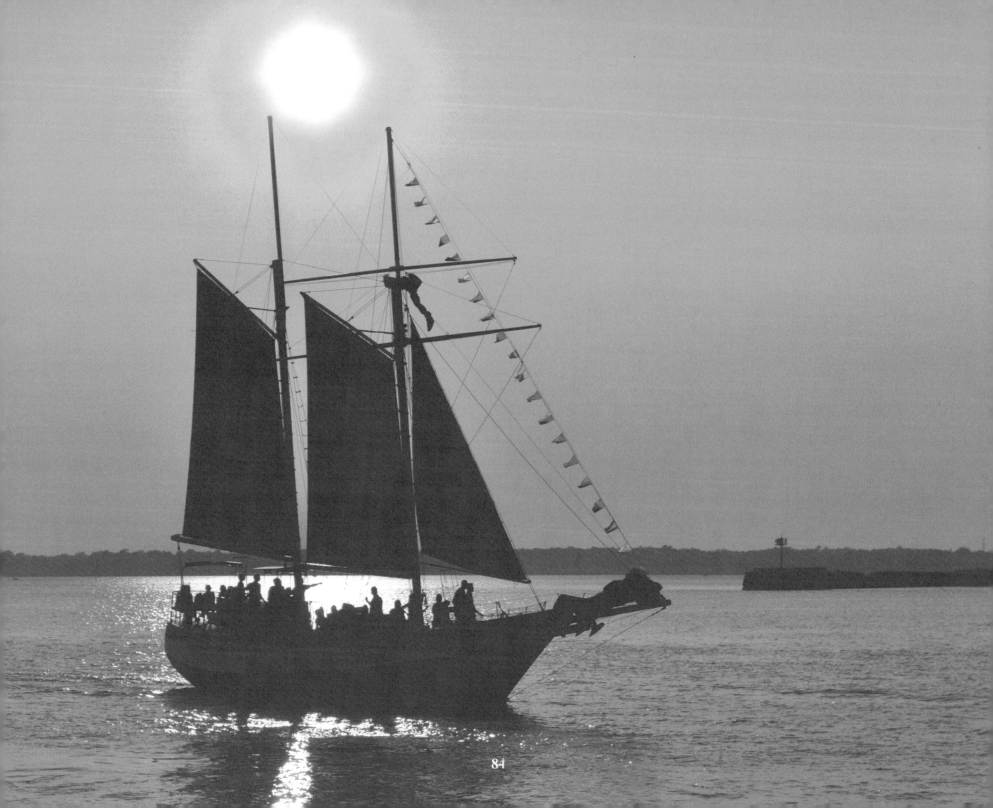

Moondance Cat *(Right:)*

Now enjoying more than 35 years in operation, Moondance Cat is a 65-passenger elite sailing Catamaran whose parallel hulls are joined by a "party" deck that supports a full bar and plenty of room for mingling.

Spirit of Buffalo *(Opposite:)*

Enjoy the skyline and the colorful sunsets over Lake Erie as you sail back in time aboard the Spirit of Buffalo. You'll truly discover the feel of traditional sailing on this classic 73-foot topsail schooner. You'll be invited to join the crew and hoist its distinctive red sails, or you can sit back, relax, and see the city in a new way.

Buffalo Tiki Tours *(Bottom:)*

Take a relaxing tour around Buffalo's Inner Harbor on a Hawaiian style Tiki Hut with you and five of your friends!

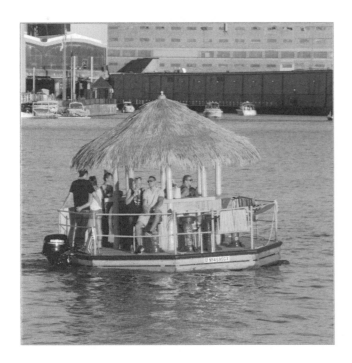

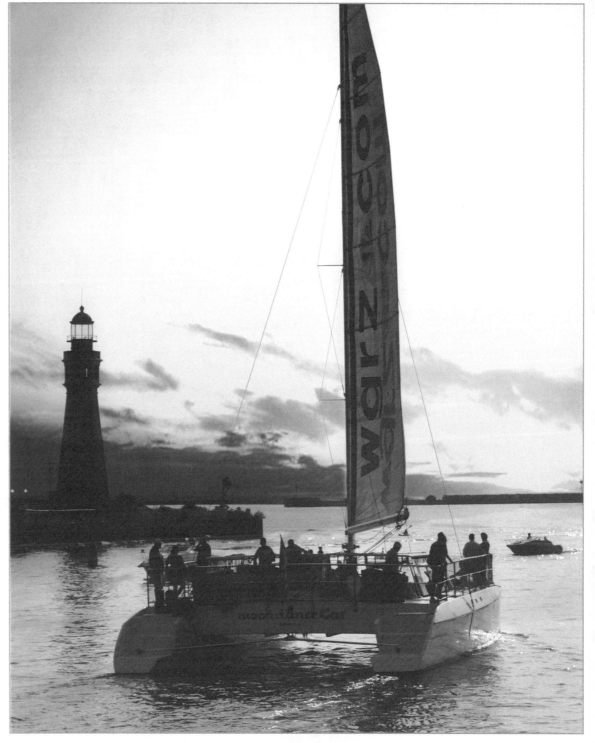

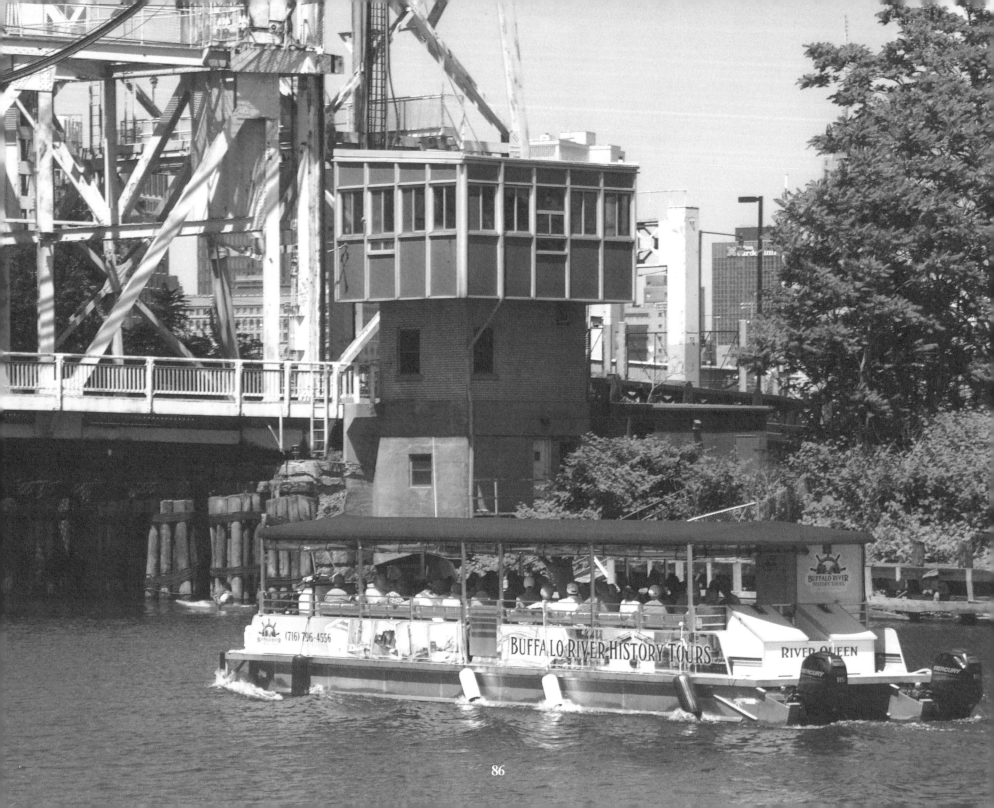

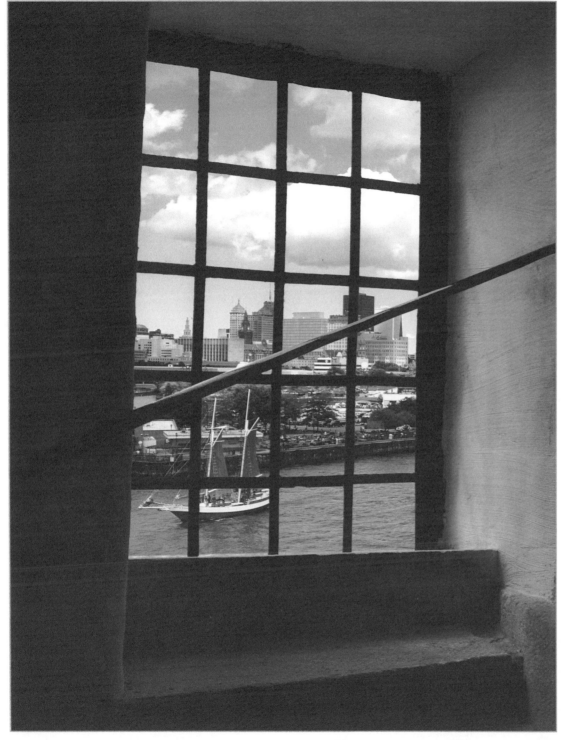

Buffalo Niagara Waterkeeper Tours

Throughout the summer, Buffalo Niagara Waterkeeper leads you back to nature with their River Tour program. Various hiking, biking, and kayaking tours are offered throughout Erie and Niagara counties. All tours are led by knowledgeable ACA-certified kayak trainers and Red Cross First Aid and CPR certified. Experience the beauty of the Buffalo and Niagara River ecosystems, watch for birds and wildlife in the heart of the City of Buffalo, and learn about what's happening along the water's edge. Tours are free, but participants must register ahead of time.

Buffalo River Historic Tours (Opposite)

Take a cruise through time where you'll hear the story of the Erie Canal, Buffalo's history as the largest grain port in the world, and experience the nation's largest collection of standing grain elevators from just a few feet away. Come travel along the waterway that made Buffalo one of the biggest and wealthiest cities in the world as you gaze up at the magnificent structures that drove its growth. It's one of Buffalo's most unique cultural experiences and one that you won't soon forget! The 90-minute narrated cruise boards at the Commercial Slip on Central Wharf at Canalside.

Buffalo Lighthouse Tours (Left:)

Grounds with historic artifact displays open to the public during posted hours, free (donation requested); tower opens on scheduled tour days or by appointment, for per-person or group donations. To book a guided group tour, a reservation is required with a minimum of 15 people. Group tours have more time to view the panoramic Buffalo waterfront vista from the premier view atop the 1833 lighthouse.

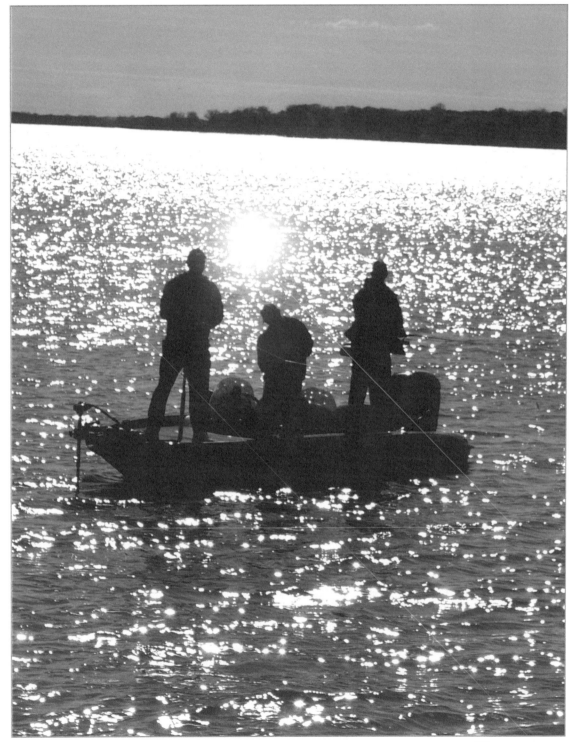

Fishing

You could easily get hooked on Buffalo-Niagara fishing. Every year roughly 50 million Americans go fishing, known as the most leisurely of sports but not one to be taken lightly. There are thousands of great fishing spots in North America, and each year Bassmasters ranks the Top 100. Buffalo on Lake Erie each year ranks in the Top Five, presently coming in at Number Three.

Just how good is the fishing near Buffalo? Our end of Lake Erie has been called the smallmouth bass capital of the world. One minute from downtown, the Buffalo Harbor offers some of the world's best musky fishing. And Lake Erie is a world-class walleye fishery, where trophy fish are routinely taken.

Most anglers focus on a 20-mile radius of Buffalo, an exceptional section of Lake Erie. In the shallow bays and marinas, you'll find largemouth to abound, and the

The Blackrock Canal, accessed from Unity Island Park, is a favorite fishing hole for area residents. *(Below:)*

Ice fishing huts and men sitting on buckets dot the landscape of Buffalo Harbor Park in winter. *(Opposite:)*

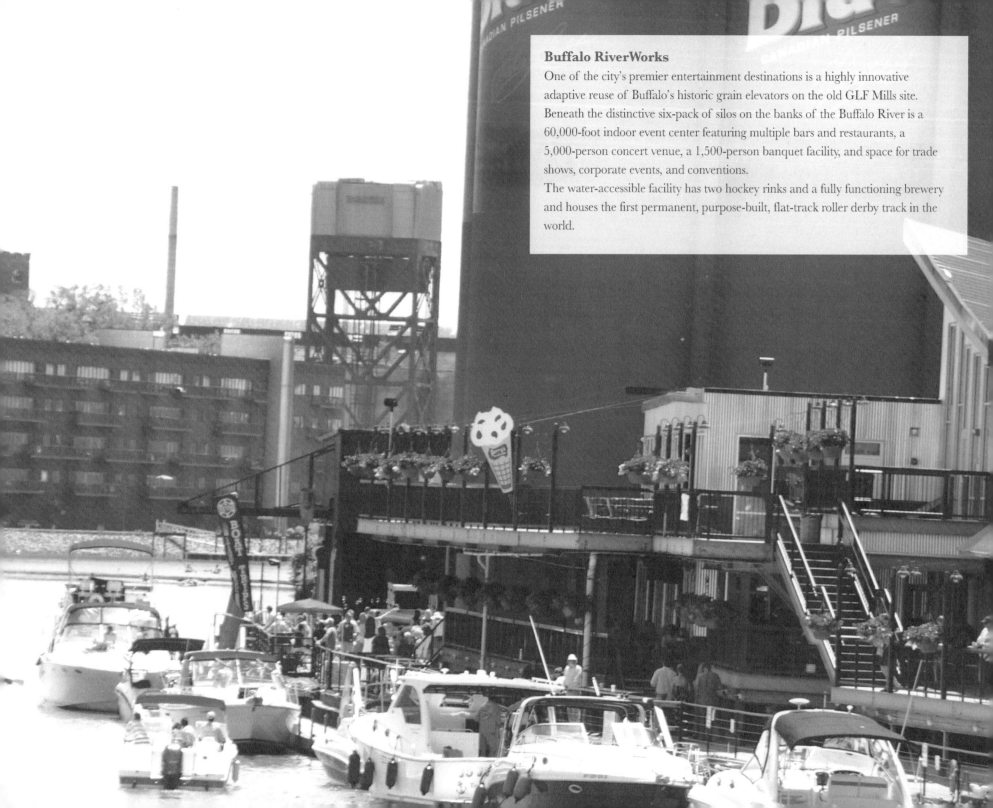

Buffalo RiverWorks

One of the city's premier entertainment destinations is a highly innovative adaptive reuse of Buffalo's historic grain elevators on the old GLF Mills site. Beneath the distinctive six-pack of silos on the banks of the Buffalo River is a 60,000-foot indoor event center featuring multiple bars and restaurants, a 5,000-person concert venue, a 1,500-person banquet facility, and space for trade shows, corporate events, and conventions.

The water-accessible facility has two hockey rinks and a fully functioning brewery and houses the first permanent, purpose-built, flat-track roller derby track in the world.

Yours To Enjoy

Buffalo has a well-earned reputation for our love for food and consuming fermented adult beverages, and our waterfront has dining opportunities ready to fulfill this passion.

You can park, dock, pedal, paddle, or zipline in for whatever you're hankering for.

There are grab-and-go burgers at The Dish, fine seafood dinners at Templeton Landing, or cones at Bryce's Ice Cream at Canalside. You can enjoy a cocktail in the shadow of a battleship at Liberty Hound or a cold one in an Adirondack chair at The Pointe Beer Garden.

Or choose your view, watching sailboats entering the lake at The Hatch, a football game on a ginormous screen at 716, or a spectacular sunset over a marina at Charlie's Boatyard.

Our waterfront checks every box.

There are plenty of choices for historic waterfront pub grub, too. Along the Buffalo River, some old salty taverns like Swannie House or Gene McCarthy's are still favorite haunts for locals, mill workers, and sailors for decades and decades back to when our waterfront was likened to the bustle of the Barbary Coast.

Liberty Hound Restaurant - Photo courtesy of Kurt Zeckmann

The Hatch Restaurant at Erie Basin Marina

Art Is Everywhere

Shark Girl *(Left:)*
On one of the the bridges crossing the re-watered canals, Shark Girl patiently sits in her best dress, hands folded, and legs daintily crossed. This lonely half-shark, half-girl is waiting for a companion to come join her on her boulder. It's a tantalizing invitation to initiate a friendship and perhaps have your picture taken with her.

Grain Elevator Lighting *(Opposite:)*
In 1901 the city of Buffalo, New York hosted the Pan-American Exposition, which featured dazzling displays of electricity, inspiring awe in its visitors and earning it the nickname the "City of Light". In 2015, thanks to a dynamic permanent art installation, Buffalo's industrial heritage is cast in a spectacular new light. The Connecting Terminal Grain Elevator, easily seen from the boardwalk at Canalside, is the canvas for this breathtaking light show. It beautifully projects our four seasons as though being viewed through the lens of a kaleidoscope.

Kinetic Sculpture at Wilkenson Pointe *(Below:)*
Taking full advantage of the seemingly constant wind from the lake move these whirligigs designed and fabricated by artist Lyman Whitaker.

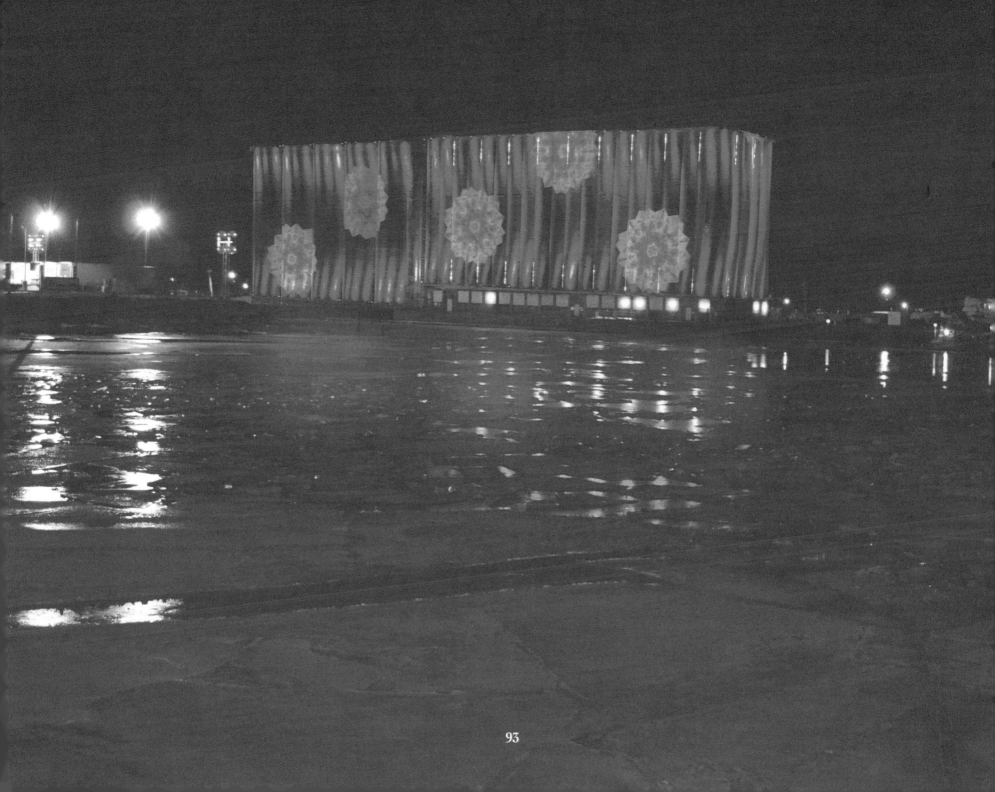

Parks & Gardens

Wilkeson Pointe *(Left:)*

"Wilkeson Pointe" is Buffalo's newest park located on the Outer Harbor and honors Samuel Wilkeson. He was the early mayor credited with getting the Erie Canal terminus located in Buffalo and constructing the breakwater. The park is open seven days a week and offers public access along the entire length of the perimeter and water's edge. The park opened in 2013, adjoining Times Beach Nature Preserve, a long-ago sand beach that is now the site of stored, dredged "materials" from other parts of the Buffalo River rectification process.

A former industrial site, the park was made only after the storage of the Lake Erie ice boom was moved elsewhere along the Buffalo River. With this land freed up, Wilkeson Pointe's 20-acre waterfront spread features volleyball courts, a gazebo, a fishing pier, a sand beach, bike paths, "natural" playgrounds of boulders and driftwood, a slide (built into a hill), pedestrian bridges, a kayak "roll-in" launch, restrooms, picnicking areas, and an array of beautiful kinetic wind sculptures.

The park has many human-made rain gardens, native-planted hills and berms, and naturalistic "no-mow" areas. An emphasis was obviously trying to make it low on maintenance and high on returning the space closer to its natural state.

Gardens at Erie Basin Marina *(Opposite:)*

The Gardens at the Erie Basin Marina are more than just an amazing explosion of floral color; it's a test garden for companies that hybridize flowers for the home gardener. Brimming with over 300 varieties of annuals gracing our waterfront, this is a vital proving ground supported by many seed companies testing flowers in this climate and location.

The gardens start at the entrance and continue throughout the Erie Basin Marina. These gardens are unusual because they are specialty annual trial gardens. Visitors can view specialty cultivars that are grown and evaluated for the coming years. There are new annual varieties – more than 3,000 plants! – from all over the world. All plants are clearly labeled. There are areas of paved walkways, as well as some grassy areas around the marina.

"I love when visitors stop, ask questions, and share their passion about gardening. It's not an interruption. I start planting early in the spring. By the time people come down here, it's summer and 80 degrees."

– Stanley Swisher, Superintendent of Grounds
Erie Basin Marina

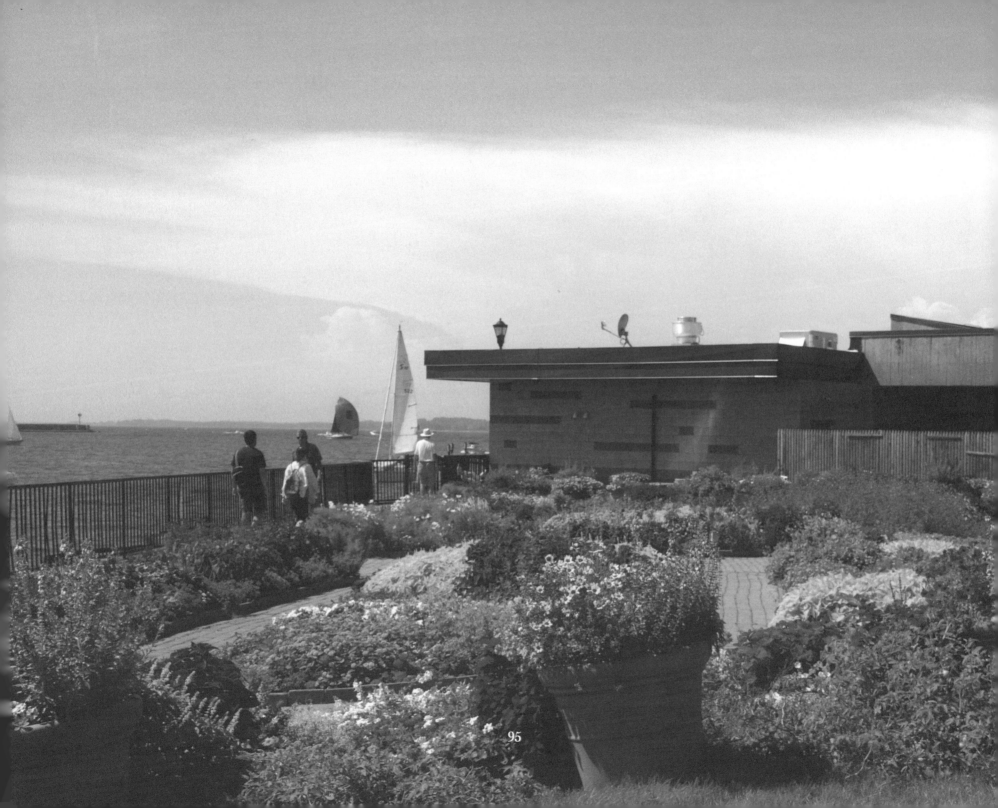

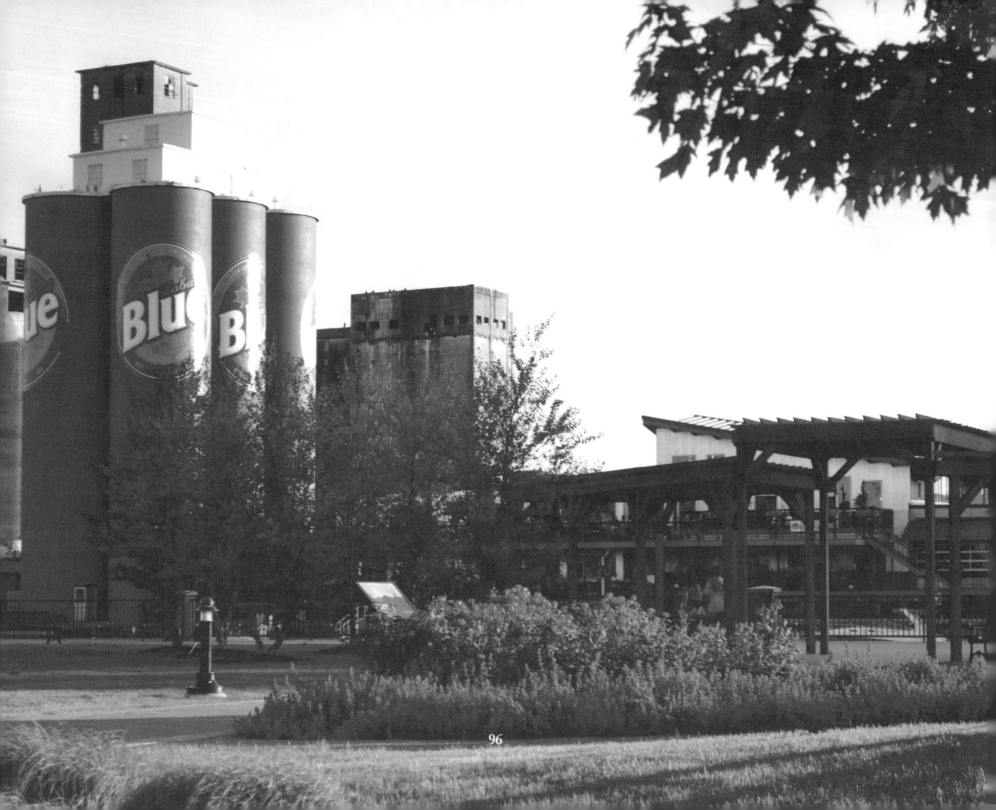

Buffalo River Fest Park *(Opposite:)*

Located in Buffalo's "Historic Old First Ward" is Buffalo River Fest Park, more often referred to as Peg's Park by the locals as an homage to Peg Overdorf, whose vision and sheer force of will helped to reclaim a stretch of industrial debris and overgrown weed and transform it into a beautifully landscaped park. The park features public boat docks, a wharf and boardwalk, picnic areas, a pergola, and lush gardens It plays host to the annual "Buffalo River Fest" celebration held each June and live music on Wednesday evenings. A robust network of bike trails provides connectivity with other waterfront destinations.

Mutual Riverfront Park *(Top Right:)*

Situated at the corner of South Street, adjacent to Buffalo's historic Elevator Alley is Mutual Riverfront Park. It was built and is owned by the New York Power Authority and named after the old Mutual Rowing Club that once stood at this location. The park features several rain gardens planted with a beautiful array of flowers, a walking path with interpretive signage, and an easy-to-use kayak launch.

The Mutual Boat House, a replica of the historic Mutual Rowing Club, provides a facility to store kayaks and canoes, making kayaking and canoeing on the Buffalo River easy and accessible. The second building houses the Valley Community Association's Waterfront Memories and More Heritage Center.

Gallagher Beach *(Bottom Right:)*

In 1998, freshman Assemblyman Brian Higgins gained funding to improve conditions at Gallagher Beach, a small unimproved tract of land at the tip of the NFTA-owned land. The result is a mecca for water sports and lakeside fun with launching areas for wind surfers and jet skiers. This multi-functional community gathering site has a new pavilion, a boardwalk, a protruding fishing pier, and rarely equaled sunsets.

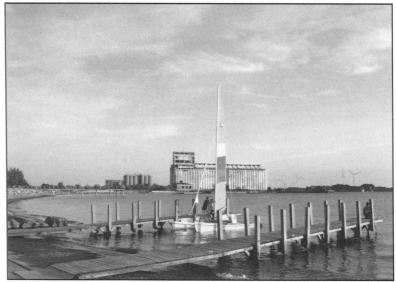

Nature

Our waterfront has designated nature preserves and as-yet undesignated parcels and acreage known to lure birds and other wildlife into taking up residency or migrating through. Two of the designated preserves, Times Beach and Tifft Nature Preserve, were each once home to other high purposes at first (one a farm, the other a sandy beach) and each sadly evolved into waste and dumping grounds. Time and nature prevailed to form a refuge for wildlife that today beckons safe future prospects for all.

Times Beach is a nature preserve for wildlife native plants with unique habitats, including forested areas, wetlands, uplands, and a pond. Acting as their gateway to the Niagara River Corridor "globally significant" Important Bird Area, to date over 240 species have been identified here, making it one of the most important bird conservation sites in the Great Lakes. It is open to the public to enjoy its series of trails, boardwalks, overlooks, and observation blinds.

Times Beach Nature Preserve's 50 acres may seem small compared to its counterpart down the road, Tifft Nature Preserve, which boasts some 264 acres and is one of the country's largest urban nature preserves. The vast spread of Tifft Nature Preserve allows for more of an activity park within a nature preserve setting. Tifft was designated in 1976 as a nature refuge dedicated to conservation and environmental education. Visitors enjoy over five miles of nature trails with three boardwalks with viewing blinds in and adjacent to a large cattail marsh.

(Opposite:) A Times Beach wildlife observation deck. *(Bottom left:)* A Great Egret at Times Beach Nature Preserve
(Bottom right:) A rare "Ghost Deer" at Tifft Nature Preserve.

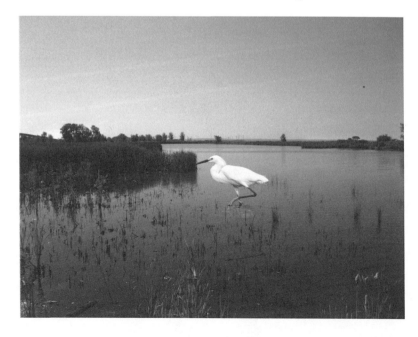

A Place To Simply Relax

Why go to the waterfront? That doesn't need an answer. What do you plan to do? That doesn't require an answer, either. Hanging out is all you need. There's so much to see and to feel.

Hanging out by the waterfront is the winning ticket of what most people by waterfronts do, whether from the home town or a tourist on a fresh air walking weekend prowl. Our waterfront boasts thousands of visitors each weekend.

Park your car, unfold a chair, and give a stare. Watch the day go by.

Lollygag days in the sun, for sure, all just hanging out as our city embraces parkways, walkways, gardens, and groves, streaming along the grid against freshwater smells and sounds, and scenes of activity far yonder to the horizon.

Come hang out. You'll notice something remarkable, too. While young as a rebounding waterfront, you'll see throngs of friendly people, Buffalo neighbors, and gracious tourists. We are indeed a City of Good Neighbors, more like cousins who share a large couch. Our new Buffalo waterfront teems with life and yearning, in a togetherness kind of way.

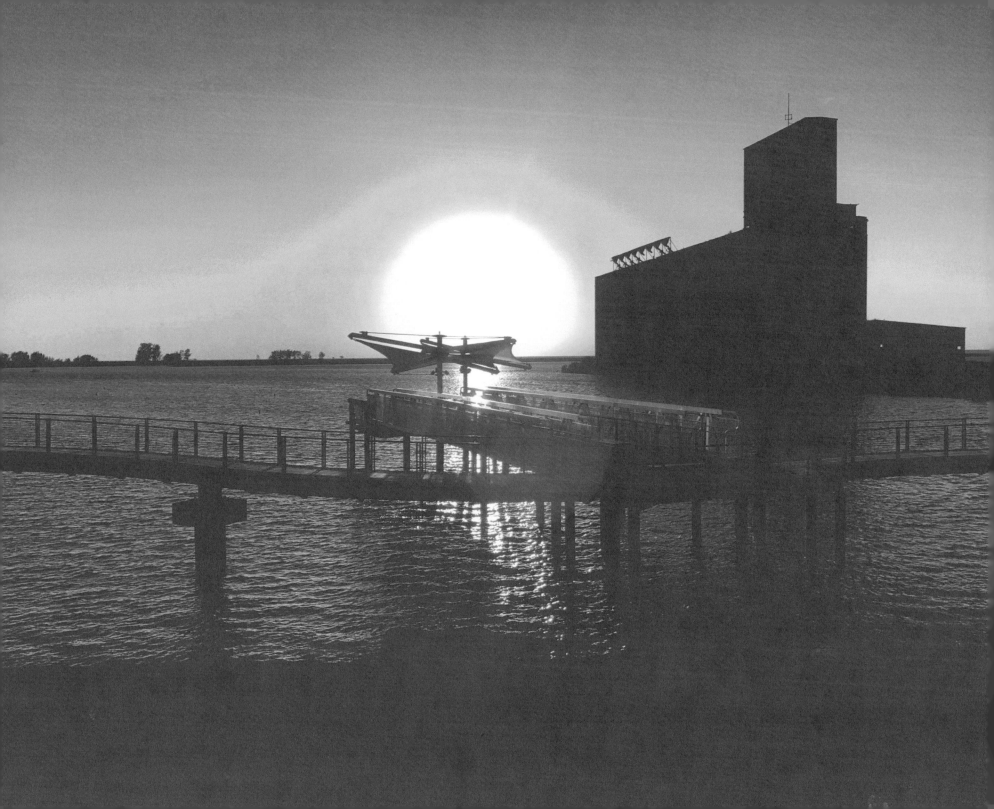

Epilogue

This book is destined to have a very happy ending.

It just hasn't been written yet.

Our waterfront is bustling at a pace few thought was possible. As you stand and marvel at the Buffalo waterfront today as a vibrant place to work, rest, and play, it's easy to forget that it wasn't all that long ago that it was a gritty, crime-ridden center of trade. In recent years, the inner and outer harbor have seen massive amounts of progress, but there are miles to go before we rest.

With barrels full of dedicated private and public money and no shortage of hope, where we are today by no means represents the completion of this Renaissance, but merely a brief coffee break to admire where we are, where we've been, and where we're going.

There are many new and exciting projects well underway. There is also a long list of initiatives well into the planning stage to attract a critical mass of private investment and enhance the waterfront's enjoyment for residents and tourists.

Our foot is firmly on the gas pedal, and there is a palpable excitement about what is around the next corner. Once again, we're "Talkin' Proud" because there truly is so much to love.

"Today there are possibilities and opportunities in place here in Erie County that our forefathers could never have imagined."

Mark C. Poloncarz
Erie County Executive

"It is a 'special' time in our City's history – we are in the midst of a transformation that will be felt for generations to come."

Byron W. Brown
Mayor, City of Buffalo

About The Authors

Captain Bill Zimmermann - Author

Bill Zimmermann is a USCG licensed captain whose decades of service on the Buffalo waterfront include owning/operating Seven Seas Sailing Center, one of the country's oldest community sailing schools. It's currently in its 51st year. He is on the Buffalo Lighthouse Association board and is one of the pioneers involved in restoring the South Buffalo Lighthouse. His many collaborations with Dr. Mark Donnelly have included the production of several waterfront festivals and annual waterfront 911 ceremonies, among other waterfront venues.

Bill has published over 300 articles for Buffalo Rising over the years featuring Buffalo history anecdotes. His first of an ongoing Allentown book series features Jake Knight, The Allentown Private Eye.

Bill's professional background has focused on the development of environmental science products and programs, and he currently serves as President and CEO of Newton Wind Tech, Inc., a commercial wind turbine development company.

Mark Donnelly, Ph.D. - Co-Author/Photographer

Dr. Mark Donnelly is an author, artist and educator; a passionate waterfront activist; a proud husband and father; and a man seldom separated from his camera. He's combined his passions for cooking and the waterfront by naming his sailboat Bacon.

Dr. Donnelly has written several books that showcase our city: *The Fine Art of Capturing Buffalo, Frozen Assets, Statuesque Buffalo, There's So Much To Love,* and *Shovel Ready City.* His newest project is *A City Built by Giants,* a book honoring the architectural genius that surrounds us. Besides creating beautiful books about this city, Mark has also written a series of children's books and novelty cookbooks.

As an award-winning photographer, Mark's work has appeared in dozens of regional exhibitions and galleries, including the Albright-Knox Art Gallery, the Burchfield Penney Art Center, Rodman Arts Centre, CEPA Gallery, The NACC, Big Orbit Gallery, Seattle Art Museum, ZGM Gallery, and the Art Gallery of Hamilton.

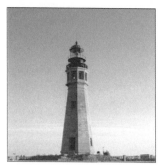
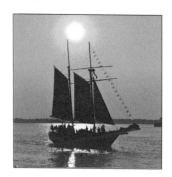
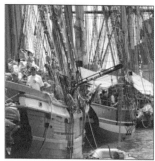

Celebrating Buffalo's Waterfront

Written by Captain Bill Zimmermann & Mark Donnelly, Ph.D. | *Photography by Mark Donnelly, Ph.D.* | *Foreword by Mike Vogel*

It's a great time to discover, explore, and be an active part of Buffalo's dynamic waterfront.
On, near, or under the water, child or adult, there's something for everyone to love.
Our waterfront is now a destination full of excitement and has a palpable new energy
that's positively a cause for celebration.
This book captures our waterfront's storied past and its spectacular transformation to where we are today.
The best chapters have yet to be written.

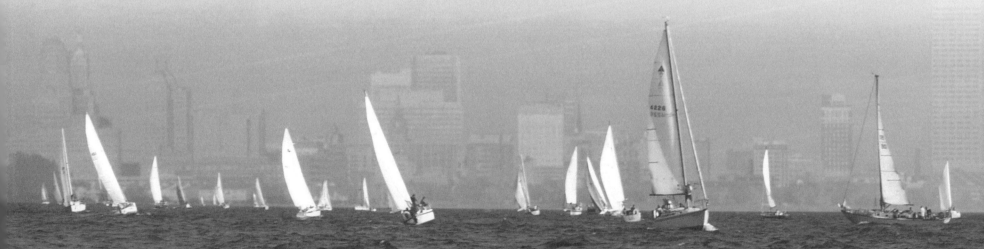

RPSS - ROCK PAPER SAFETY SCISSORS PUBLISHING - BUFFALO, NEW YORK

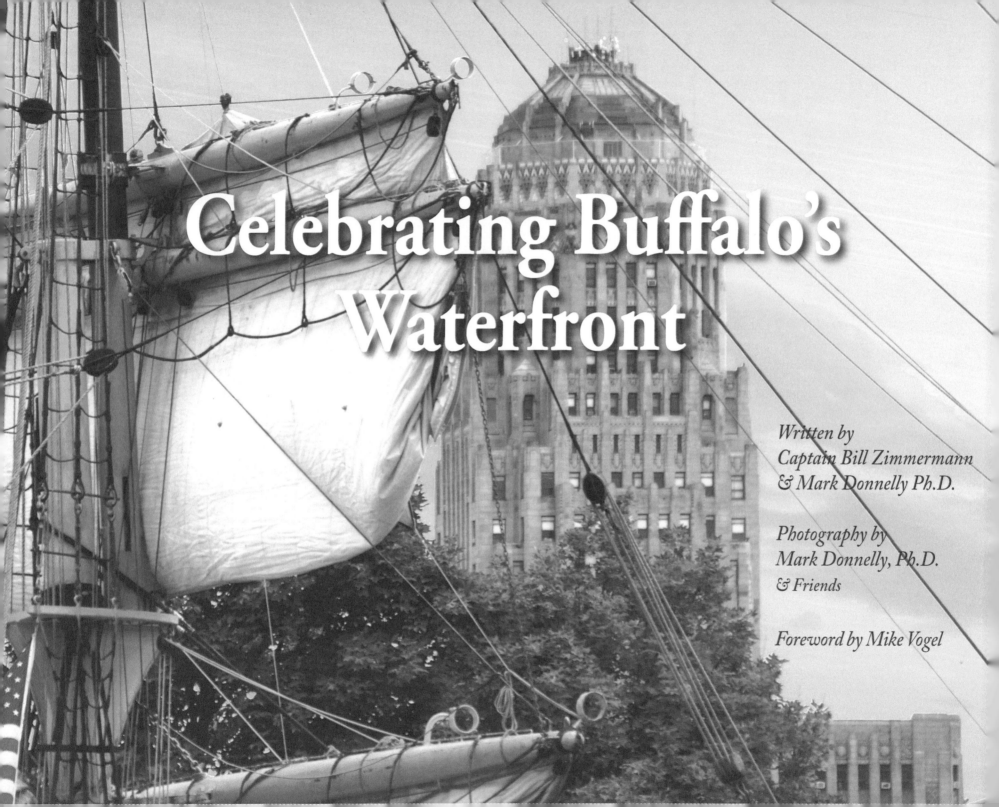

Celebrating Buffalo's Waterfront

Written by
Captain Bill Zimmermann
& Mark Donnelly Ph.D.

Photography by
Mark Donnelly, Ph.D.
& Friends

Foreword by Mike Vogel

CPSIA information can be obtained
at www.ICGtesting.com
Printed in the USA
LVRC092328260521
688628LV00004B/98